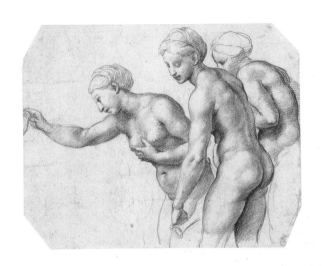

ITALIAN PAINTINGS
and DRAWINGS
The Royal Collection

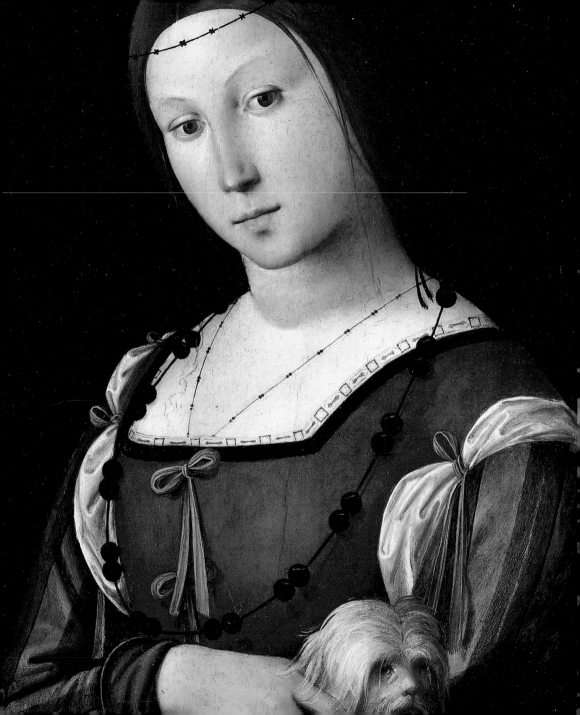

ITALIAN PAINTINGS
and DRAWINGS
The Royal Collection

ROYAL COLLECTION PUBLICATIONS

SCALA

Published in 2007 by Scala Publishers Ltd
in association with Royal Collection Enterprises Ltd

Scala Publishers Ltd, Northburgh House, 10 Northburgh Street,
London EC1V 0AT, UK. www.scalapublishers.com

ISBN–13: 978-1-85759-486-7
ISBN–10: 1-85759-486-X
SKU: 155390

British Library Cataloguing-in-Publication data: A catalogue record for this
book is available from the British Library.

The text of this book is abridged from *The Art of Italy in the Royal Collection:
Renaissance & Baroque* by Lucy Whitaker and Martin Clayton, published by
Royal Collection Publications in 2007.

Text edited by Rosalind Neely
Designed by Nigel Soper
Project Manager, Scala: Oliver Craske

Printed in Italy by Studio Fasoli, Verona
10 9 8 7 6 5 4 3 2 1

In the measurements of works, height is followed by width. The dates of
monarchs' reigns are given in brackets, preceded by the abbreviation 'r.'

Page 1: Raphael, *The Three Graces* (pl. 10)
Page 2: Lorenzo Costa, *Portrait of a Lady with a Lap-dog* (pl. 21; detail)
Pages 6–7: Caravaggio, *The Calling of Saints Peter and Andrew* (pl. 68; detail)

CONTENTS

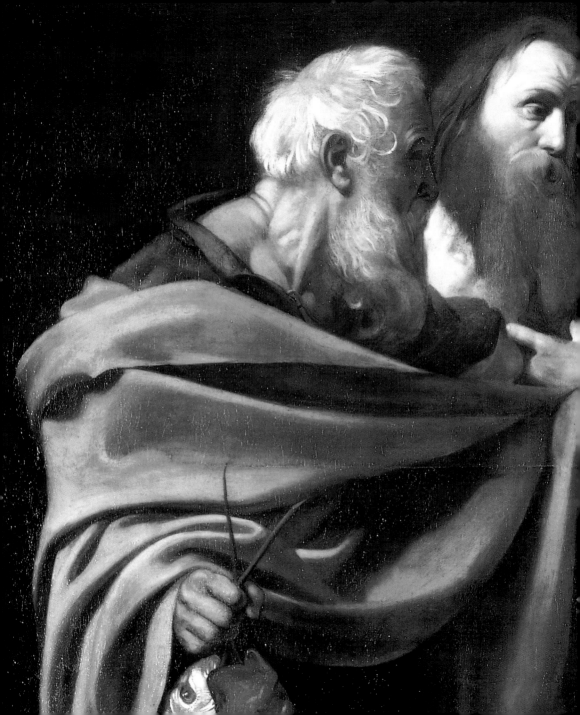

Introduction

Thanks to the interest taken by the British royal family in Italian art of the Renaissance and the Baroque, from Tudor times to the Victorian era, the Royal Collection today has rich holdings of Italian paintings and drawings from these periods. The quality of the collection can largely be attributed to the interests and passions of a few individuals, such as Charles I, Charles II, Frederick, Prince of Wales, George III, and Queen Victoria and Prince Albert.

During the Renaissance and Baroque, Italy saw a remarkable flourishing of the arts. The Renaissance was an extraordinary period of great upheaval in all areas of cultural endeavour, not only of art, but also architecture, literature and philosophy, which had its origins in the fourteenth century and continued into the sixteenth. During this period artists began to take inspiration from classical artists and thinkers, with a new emphasis on the importance of the human body. The central Italians Leonardo da Vinci (fig. 1), Michelangelo and Raphael perfected, with a Florentine emphasis on the discipline of drawing, visual languages that had a far-reaching influence on their successors. In Venice and northern Italy, artists such as Titian developed the medium of oil on canvas to create new illusions of reality with colour and light.

Art of the Baroque era – roughly from 1600 to 1750 – was intended to appeal more directly to the emotions of the spectator. European painting and sculpture became highly illusionistic, with clear subject matter and exaggerated movement, to heighten a sense of drama and exuberance. There was no single Baroque style, and the different approaches ranged from the revolutionary earthiness of Caravaggio to the cool classicism of Poussin.

Over the years Italian paintings and drawings from both these periods

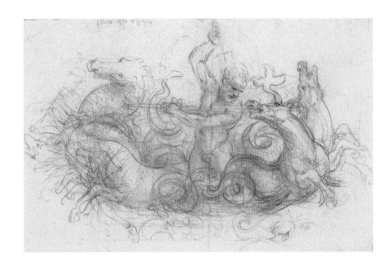

have entered the Royal Collection in significant numbers. Today it holds some of the best examples of these works in the world. The collection shows the extraordinary variations in style and outstanding quality of work produced by Renaissance and Baroque artists. The paintings and drawings come in a wide range of media – oil; pen and ink; charcoal; black, red or white chalk. Some of the drawings are finished works, while others are preparatory studies, fragments or sketches, intended for other works of art, such as frescoes, altarpieces for chapels, or tapestries. They deal with subjects that range from the classical and religious through the secular, pastoral and mythological to the practical, and draw on many influences for their sources of inspiration.

The Tudors

Exchanges of works of art have often played a role in political alliances. Early in 1504 Henry VII (r. 1485–1509) sent ambassadors to Italy to present Guidobaldo, the eldest son of Federigo da Montefeltro, Duke of Urbino, with

the Order of the Garter. This was part of Henry's plan to persuade Pope Julius II to allow the marriage of the Prince of Wales, the future Henry VIII, to his brother's widow, Catherine of Aragon.

In 1506 Baldassare Castiglione set out for England to represent the Duke at the ceremony of his installation as Knight of the Garter at Windsor. There is an old tradition, though with no documented evidence, that Castiglione brought with him, as a gift for the King, the small panel of *St George and the Dragon* by Raphael (now in the National Gallery of Art, Washington, DC), painted around 1505–6. If this story were true, then this would have been the first major Italian Renaissance painting to enter the Royal Collection. However, a hundred years later the painting belonged to the 4th Earl of Pembroke, from whom Charles I acquired it in exchange for a book of Holbein drawings.

Henry VIII (r. 1509–47) used Italian sculptors, painters and craftsmen for his building projects (though most of their work has now disappeared) and for his parents' tomb, which survives in Westminster Abbey and was carved between 1512 and 1518 by the sculptor Pietro Torrigiani.

At this time tapestries were more highly regarded and more expensive than paintings. The English had their first experience of the magnificence of the Italian High Renaissance in 1542, when two sets of tapestries arrived at Henry VIII's court: the *Acts of the Apostles*, designed by Raphael, and the *Triumph of the Gods* (known as 'The Antiques'), designed by two members of his studio, Giovanni Francesco Penni and Giovanni da Udine. Henry VIII's 1547 inventory records more than 2,700 tapestries, and even a century later, when the Royal Collection contained masterpieces of Italian painting, tapestries were the most valuable pieces in the Commonwealth Sale of 1649–51 (see pages 24–25).

The English Reformation led to a change in emphasis in

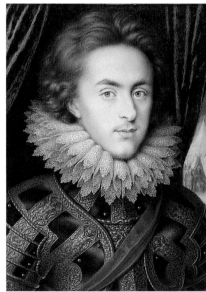

Fig. 2
**ISAAC OLIVER
(C.1594–1647)**
*Henry, Prince of Wales,
c.*1610-12
Watercolour on
vellum laid on card,
12.8 x 9.8 cm

the Royal Collection. Henry VIII's break with the Catholic church, and the ensuing religious differences between his children, led to a shift away from religious subject matter. In Queen Elizabeth I's reign, there was a preference instead for portraits of the Queen, her family, the supporters of her dynasty and foreign rulers, emphasising the lineage and alliances of the monarch. While English patrons generally looked first to the Low Countries or Germany for their portrait painters, they also began to acknowledge the distinctive contribution of Italian artists. Titian's portrait of Philip II had been sent by the Queen of Hungary to Mary I (r. 1553–8) in 1553 with these instructions (in French): 'it will serve to tell her what he is like, if she will put it in a proper light and look at it from a distance, as all Titian's paintings have to be looked at'. This advice suggests that the English audience needed guidance in knowing how to appreciate Italian painting.

In 1575 Federico Zuccaro paid a brief visit to the court of Elizabeth I (r. 1558–1603), probably at the request of Robert Dudley, Earl of Leicester, and painted Dudley and the Queen. The full-length portraits are lost, but the drawing of the Queen, dating from May 1575 (British Museum, London), is a rare portrait taken from life; its allegorical ermine and snakes are similar to those appearing in Zuccaro's *Calumny* (pl. 8).

Henry, Prince of Wales

Both Prince Henry (fig. 2) and Charles I, the sons of James I (r. 1603–25) and Queen Anne of Denmark, inherited their mother's taste for art. She reputedly preferred pictures to the company of living people.

There were more possibilities to acquire Italian art, particularly Venetian art, at the beginning of the seventeenth century. After Henry VIII's break with Rome and Elizabeth I's excommunication in 1570, Venice was the only Italian state with which the English had a political understanding. The Anglo-Spanish peace treaty of 1604 forged stronger links between England and the Continent and made travel easier. It was at this time that

a succession of astute English ambassadors served in Venice – Sir Henry Wotton in various periods between 1604 and 1623; Sir Dudley Carleton from 1610 to 1615; and Sir Isaac Wake from 1624 to 1630. All were involved in negotiations for the export of works of art.

On the recommendation of Wotton, Lord Salisbury acquired Palma Giovane's *Prometheus* in 1608, and gave it to the young Henry, Prince of Wales two years later. Shortly afterwards, Prince Henry spent £408. 17*s*. 6*d*. (about £50,000 in today's currency) on the first large shipment of Venetian paintings direct from Italy, which probably included works by Tintoretto, Bassano and Palma Giovane.

In a letter of 14 January 1611, the Venetian ambassador in London, Marc Antonio Correr, reported that Prince Henry had displayed mainly pictures from Venice in the gallery at St James's Palace that had just been remodelled by the Prince's surveyor, Inigo Jones; for the first time large-scale religious subjects and mythological ones – *Bacchus*, *Ceres and Venus*, *Prometheus* – were seen alongside the more usual portraits.

When plans were laid to marry Prince Henry to Catherine de' Medici, the daughter of Grand Duke Ferdinand I of Tuscany, the negotiations involved a gift of paintings, including one by Beccafumi, and portraits of famous Italians, including Pico della Mirandola, Machiavelli and Castruccio. Henry also asked for sculptures by Giambologna and in 1612 received a number of small bronze casts made by Pietro Tacca from his models. When they were unpacked at Richmond Palace, Prince Henry seized a bronze and kissed it, and refused to allow his younger brother, then aged 12, to have one as a plaything.

Henry gained a reputation as a discriminating collector who wanted to build up a collection to match that of Rudolf II in Prague or the Florentine court of the Medici grand dukes. When he died at the age of 18 in 1612, his collection, which included fine Italian and Netherlandish paintings, as well as coins, medals and books, was inherited by his younger brother Charles, now the heir to the throne.

Fig. 3
RAPHAEL (1483–1520)
The Conversion of the Proconsul Sergius Paulus, *c*.1514
Metalpoint, brown wash, white heightening and later pen and ink, over stylus lines, pin-pointing and black chalk underdrawing, on pale buff prepared paper, 26.9 x 35.4 cm

In 1513 Pope Leo X commissioned Raphael to design a set of tapestries of the Acts of the Apostles, to be hung in the Sistine Chapel. Raphael painted ten full-size cartoons as models for the weavers in Brussels; the seven surviving cartoons were purchased by the future Charles I in 1623. In this elaborate study St Paul strikes blind the magician Elymas, thus converting the Roman Proconsul Sergius Paulus to Christianity.

Charles I and Spain

During the lengthy and ultimately abortive negotiations for the marriage of Prince Charles to the King of Spain's sister, the Infanta Maria, the future King sought to break the deadlock by visiting Madrid in 1623 and wooing the Infanta in person. He was accompanied by some of the most knowledgeable and important art collectors in England.

King Philip IV's collection was at that time the most extensive in Europe, and his Venetian paintings in particular must have dazzled his visitors. The young King gave Charles important paintings, including Titian's *Jupiter and*

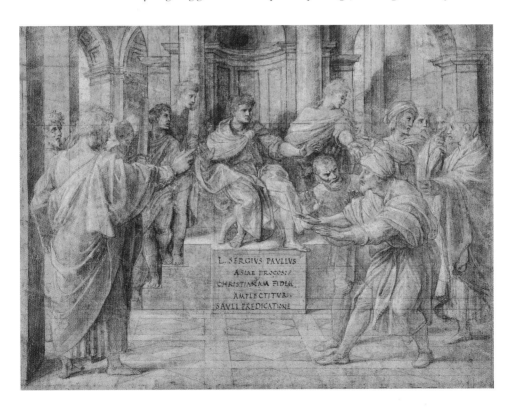

Antiope (Louvre, Paris) – known as the *Venus del Pardo* – as well as the same artist's *Emperor Charles V with a Hound* (Kunsthistorisches Museum, Vienna) and Correggio's *Holy Family with the Infant Baptist* (probably the one in the Musée des Beaux-Arts, Orléans). There was a suggestion that Philip was intending to give Charles three more Titians, presumably in the event of a successful outcome to the marriage negotiations.

Charles also found opportunities to buy paintings in Spain: Titian's *Nude Girl in a Fur Wrap* (Kunsthistorisches Museum) and *Allegory of Alfonso d'Avalos* (Louvre), and a copy of his *Christ Bearing the Cross*. He commissioned further copies of pictures in Spain, particularly by Titian. More than any other event in his life, this visit must have given Charles the determination to assemble an art collection to compete with Philip's.

It was while in Spain that Charles concluded the negotiations (through agents) to purchase from a Genoese collection the series of seven full-scale cartoons for tapestries by Raphael, depicting subjects from the Acts of Apostles. (Fig. 3 is a preparatory drawing for the cartoons.) He bought them for the relatively low price of £300, probably to provide designs for the tapestry works that had recently been founded at Mortlake. These cartoons form an essential part of the story of royal taste discussed in this volume. They are still part of the Royal Collection today, and since 1865 have been on loan to the Victoria and Albert Museum.

Although the cartoons were outstanding examples of Italian art in England, they were also functional objects. They had been cut into strips to be used directly on the looms, as was customary with the low-warp method of tapestry weaving. After Charles's death the strips were stored in wooden boxes in the Banqueting House at Whitehall and permanently reassembled by William III only in 1699.

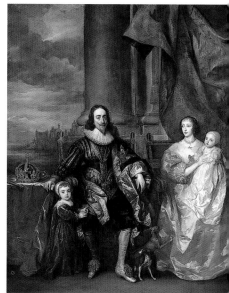

Fig. 4
Sir Anthony Van Dyck (1599–1641)
Charles I and Henrietta Maria with their two eldest children, Prince Charles and Princess Mary, c.1632
Oil on canvas,
302.9 x 256.9 cm

Barter, Art and Politics

Charles I (r. 1625–49, fig. 4) was encouraged in his collecting by a small group of the nobility, many of whom had been at the courts of his father and elder brother. The most serious and knowledgeable collector was the Earl of Arundel, who was deeply interested in European and especially Italian culture, and in the ancient civilisation of Rome. Another adviser was George Villiers, a favourite of James I and then of Charles I, who was created Duke of Buckingham in 1623. His meteoric rise at court was matched by the speed with which he accumulated a collection of art to be displayed in York House on the Strand. Buckingham owed much of his success as a collector to the advice of Balthasar Gerbier, a miniature-painter, architect and dealer from Middelburg in Zeeland. Buckingham was also a friend of Rubens and was instrumental in attracting other artists to London, including Gerrit van Honthorst and Orazio Gentileschi (pls 64, 82).

Charles I and other aristocratic collectors relied upon advisers such as Inigo Jones and Nicholas Lanier and a network of art dealers, agents and ambassadors across Europe. Daniel Nys – a Flemish merchant and the foremost art dealer living in Venice – acted as agent for the Earl of Somerset and had a wide range of contacts, including artists such as Domenico Fetti (pls 71, 79, 80), writers, and collectors such as the Earl of Arundel and Ferdinando Gonzaga, 6th Duke of Mantua.

Such men 'traded' on their collections, exchanging paintings with the King or making outright gifts in the hope of gaining political advantage. Thus the 3rd Earl of Pembroke gave the King a Giovanni Bellini and a Parmigianino in return for a 'little Judith' by Giorgione, then thought to be by Raphael. Charles I acquired Leonardo da Vinci's *St John the Baptist* (Louvre) from Roger de Liancourt, a Gentleman of the Bedchamber to Louis XIII, in exchange for Holbein's portrait of *Erasmus* (Louvre) and a Titian religious painting, which had belonged to John Donne. We can assume that in every one of these examples of royal barter, the trading partner gained

intimacy and prestige with the King. There was a close link between art and politics: an understanding of art became a useful accomplishment for a courtier. For example, Rubens was chosen by the Archduchess Isabella as her ambassador to the court of Charles I.

The Gonzaga Collection at Mantua

Charles I was acknowledged to be a discerning as well as a passionate collector, a reputation that enhanced the prestige of his court. Indeed, Rubens called Charles I 'the greatest amateur of paintings among the princes of the world'.

With his acquisition of the Gonzaga collection, which had been built up over centuries, Charles I managed, at a stroke, to gain part of the heritage and prestige of a famous Italian Renaissance court. English connoisseurs had long known of the splendours of the Gonzaga court at Mantua. The lists in the sale negotiations included Titian's *Twelve Caesars*; Raphael's *Virgin and Child with St Elizabeth and the Infant Baptist* (the '*Madonna della Perla*', now thought to be by Giulio Romano; Prado, Madrid); Andrea del Sarto's *Madonna della Scala* (Prado); Giulio Romano's *St Jerome* (untraced); Correggio's *Venus with Mercury and Cupid* (National Gallery, London) and *Venus with Satyr and Cupid* (Louvre); and Guido Reni's *Toilet of Venus* (National Gallery, London).

Also part of the purchase were many works by Giulio Romano, including *The Nativity* (Louvre); Dosso Dossi's *Holy Family* (pl. 24); and a large group of Titians. In addition, there was an important group of works by Giovanni Baglione (pl. 74) and Domenico Fetti (pls 71, 79, 80) and Caravaggio's famous *Death of the Virgin* (Louvre).

Charles I's acquisition of the Gonzaga collection was facilitated by two agents working on his behalf in Italy, Nicholas Lanier, Master of the King's Music, and Daniel Nys. Lanier had been acting for the King since at least June 1625, when he was preparing to export to England a group of pictures.

With the help of Nys, Lanier saw the Gonzaga collection and reported back to the King. It was Nys who started negotiations with Duke Ferdinando until the latter's death in 1626, and thereafter with his son, Vincenzo II.

By September 1627 some of the paintings had been moved to Murano in preparation for shipping. In December statues and busts were added. Progress was slow because Vincenzo suspected that Nys was negotiating for rival Italian powers, such as the Duke of Parma or the Grand Duke of Tuscany, and because the citizens of Mantua were angry when they learned of the impending sale.

With the death of Vincenzo II on 25 December 1627 the duchy passed to Charles I of Nevers, who needed funds for a war to secure his succession and had fewer qualms about selling the collection. Nys was able to write in triumph to the art collector Endymion Porter in April 1628 that the negotiations had gone very well. Sir Isaac Wake, the British ambassador in Venice, negotiated exemption from customs dues and, with Lanier, made arrangements for the safe journey of the paintings on the ship *Margaret*, which set sail on 15 April 1628. Lanier travelled overland with two fragile *Allegories* by Correggio and the *Madonna della Perla*, which, according to Nys, were 'the finest pictures in the world, and well worth the money paid for the whole, both on account of their rarity and exquisite beauty'.

It took another year of negotiations and a further £10,500 for Daniel Nys to persuade Charles of Nevers to include two important groups of work in the sale: the collection of sculpture, and Mantegna's *Triumphs of Caesar*. The second shipment of works of art from Mantua was eventually sent to London, after various delays, on the *Assurance*.

The total cost of the Gonzaga purchase was probably in the region of £30,000 (just over £4½ million today). It is difficult to give an exact figure because the sale was made in two parts, transport and administration of the sale are included in the sum, and the King was slow making payments. Daniel Nys was forced to send several letters to the King pleading for payment, and eventually suffered bankruptcy.

The Van der Doort Inventory

In August 1628 Charles I ordered Lanier, Inigo Jones and William George, Clerk of the Wardrobe, to make an inventory of his art collection. This lost document must have informed Abraham van der Doort's important (though incomplete) inventory of the collection in 1639, which provides a full description of paintings at Whitehall, Charles's principal residence, and lists of those at Greenwich and Nonsuch but not of his other residences. One version of the catalogue, probably written around 1640, also lists pictures in the gallery at St James's Palace.

A Dutch medallist, Abraham van der Doort had worked at the court of Rudolf II in Prague before entering the service of Prince Henry in 1611. In May 1625 Charles I made him Overseer or Surveyor of the whole collection. His inventory is an invaluable record of the provenance, size, attribution, condition, frames and arrangement of Charles's works of art. Each painting from the Gonzaga collection is methodically identified as 'A Mantua peece'. He devised a brand of ownership, or cipher, which can still be found on Charles I's paintings today, and labels, some of which also survive. His attributions reflect the high standard of connoisseurship at court.

Van der Doort recorded how the Gonzaga collection had been affected by its journey to England, especially the damage caused by contact with quicksilver (mercury) in the hold of the ship. It has been suggested that some barrels contained vermilion (or mercuric sulphide), which could have converted the lead white (basic lead carbonate) to lead sulphide, which is black. Theodore de Mayerne, the King's physician, witnessed the damage, which he put down to currants also stored in the hold with the paintings – he believed that the heat generated from the currants activated the mercury. It is uncertain what exactly happened in the ship's hold, but it was necessary to restore some of the paintings. From 1631 to 1644 there are records of payments to various individuals, including John de Critz, his son Thomas, Anthony Van Dyck, and Nicholas Lanier's uncle, Jerome Lanier, for repairing paintings damaged on the journey.

Displaying the Collection

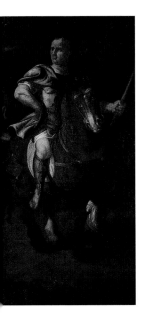

The Gonzaga collection of about ninety paintings and two hundred pieces of sculpture was incorporated into the existing Royal Collection. Although groups of paintings were broken up, the gallery at St James's Palace was a good example of sophisticated and intelligent hanging, producing a coherent arrangement of pictures to match Giulio Romano's decorations of the Palazzo Ducale in Mantua. This space contained some of the highlights of the Mantuan purchase: Caravaggio's *Death of the Virgin* (Louvre), seven of Titian's *Emperors* and Giulio Romano's series of *Emperors on Horseback* (fig. 5 and pl. 31). Van Dyck's theatrical equestrian portrait, *Charles I with M. de St Antoine* (Louvre), closed one end of the gallery, showing the King as ruler, warrior and knight in the long tradition of Antique and Renaissance equestrian monuments, framed by a triumphal arch. Three of the set of four Guido Reni *Labours of Hercules* (Louvre) were included, and it is likely that his *Death of Hercules* was on the opposite wall, facing the Van Dyck.

Historians of this period have contrasted the court of James I, which was informal, occasionally even undignified, with that of Charles I, regarded as grave, aloof and private, in imitation of Spanish court etiquette. Under King James decorum had been lax and access to the King relatively easy; Charles I revived the etiquette of Elizabeth I's reign and, in the 1630s, codified 'rules and maxims' to reform the court, with each rank of nobility given an appointed time to enter his apartments. Zuane Pesaro, the Venetian Ambassador in England, reported that the King set aside one day for public audience and only wished to be introduced to those he had requested to see.

One of the effects of these changes was to create spaces within the royal palaces that were genuinely private. The King even had new triple locks fitted to the privy lodgings at Whitehall, entrusting the keys only to a select few. Another consequence of the new emphasis on formality and the restriction of access to the King was that only a small number of distinguished visitors had the opportunity of seeing the Gonzaga collection. Much of court life must

have been perceived as culturally distinct from the rest of the nation: wealthy, sophisticated and exclusive.

Some of the finest Gonzaga paintings were hung in these 'privy' (private) spaces in Whitehall Palace. Van der Doort noted in his inventory that the King himself chose the paintings to hang in his Bedchamber, and it may be assumed that he did the same throughout the privy lodgings.

In the First Privy Room there were eleven Titians and one Correggio, with religious and secular paintings side by side. In the Second Privy Room eight paintings attributed to Titian were hung with three Polidoro da Caravaggio friezes (including fig. 7) and six panels by the workshop of Giulio Romano (including pl. 30). In the Third Privy Room there were three Titians, three Correggios, two Andrea del Sartos and the *Madonna della Perla*. In the Breakfast Chamber, Van Dyck's *Five Eldest Children of Charles I* was playfully paired with Giulio Romano's *Mermaid Feeding her Young*. The Bedchamber contained portraits of Charles's family and friends and three religious paintings. The Chair Room included a small Mantuan *Agony in the Garden* by Annibale Carracci, among a group of German and Netherlandish pictures. The Cabinet Room was filled with small and precious works of art, including bronzes and 73 smaller paintings.

Charles I and Italian Painting

The sums spent by Charles I on his art collection and new buildings may in fact have been modest compared with those paid by other aristocrats and foreign princes. He spent less on great public ceremonies than Elizabeth I or James I: James's wedding for his daughter, Princess Elizabeth, cost about £100,000, more than three times the cost of the Gonzaga collection.

Charles I's passion for painting played an important part in a new *rapprochement* between the English Crown and the Papacy. His marriage in 1625 to Henrietta Maria, a Catholic princess and goddaughter of Pope Urban VIII, led to gifts of paintings from the Pope's nephew, Cardinal

Francesco Barberini, no doubt in the hope that Charles might incline more favourably towards the Catholic Church. In January 1636 seven paintings arrived; further gifts were brought by the new papal agent George Conn in July 1636 and again in February 1637. The same year Henrietta Maria displayed religious pictures she had received from the Barberini family in the chapel at Somerset House. These gifts were decried by Parliamentarians such as William Prynne, who protested that they were 'vanities brought from Rome to seduce the King'.

Reni's four *Labours of Hercules* were already in the Royal Collection (as part of the Gonzaga purchase) when, in March 1637, Henrietta Maria commissioned, through Cardinal Francesco Barberini, a ceiling painting by Reni for her bedroom in Greenwich. The painting of *Bacchus and Ariadne* reached the Queen only after she had fled to France during the Civil War; by 1648 she was trying to sell it, and subsequently it was almost completely destroyed by the widow of its new owner, because of its excessive nudity.

Charles I's attempts to lure Italian artists to London were only moderately successful; in the 1620s Guercino refused an invitation on the grounds that he did not want to live in an English climate and work for heretics. In 1626 Orazio Gentileschi, who had previously worked in Paris for Henrietta Maria's mother, Marie de' Medici, was brought to London by the Duke of Buckingham. His style appealed more to the Queen than the King. Henrietta Maria commissioned *Joseph and Potiphar's Wife* (fig. 6 and pl. 64) and the large ceiling painting of *An Allegory of Peace and the Arts* (1638–9; now Marlborough House, London) for Greenwich. His daughter Artemisia Gentileschi also spent two or three years in London. She probably presented the King and Queen with her sophisticated self-portrait (pl. 78) and they owned several other paintings by her.

The King's difficulties at home – military campaigns in Scotland and Ireland, and repeated conflicts with Parliament, ultimately leading to the Civil War of 1642–5 – prevented him from pursuing the collections of Cardinal Ludovico Ludovisi or Bartolomeo della Nave, both of which became available

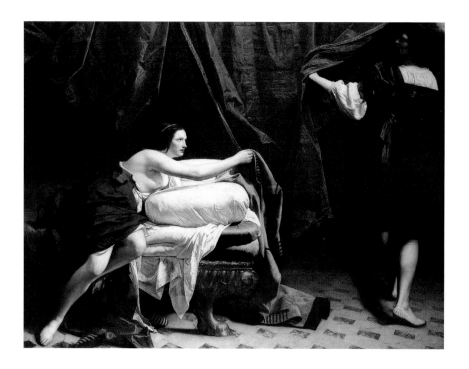

in 1637. The only major purchase made late in his reign was a group of paintings, including the set of panels by Polidoro da Caravaggio (fig. 7 and pl. 5) and Caravaggio's *Calling of Saints Peter and Andrew* (see pages 6–7 and pl. 68), bought in 1637 from William Frizell, who had held the office of Postmaster General for Foreign Parts between 1632 and 1635.

Above: Fig. 6
Orazio Gentileschi
(1563–1639)
Joseph and Potiphar's Wife,
c.1630–2
Oil on canvas,
206 x 261.9 cm (see pl. 64)

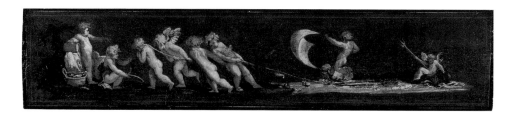

English Collectors of Drawings in the Age of Charles I

In common with most other collectors of the period, Charles I seems to have had no interest in drawings. He owned only one major group of drawings – by Hans Holbein – which he had inherited from his elder brother, and he exchanged that early in his reign for Raphael's *St George and the Dragon* (National Gallery of Art, Washington, DC). Most of the contents of the Cabinet Room at Whitehall listed in Van der Doort's inventory had been given to Charles I; only one album was bought by the King, and it would have been of interest not because the works in it were drawings, but because they were portraits. It is unlikely that significant holdings of drawings housed elsewhere would have escaped Van der Doort's attention, and his inventory may be taken as a reliable record of the King's holdings at that time.

We know of only three individuals in England during the reign of Charles I who were especially interested in drawings. Nicholas Lanier may have been both a dealer in drawings and a collector, and the small star marks (of five or eight points) stamped on many Italian drawings have traditionally been associated with him. It now seems that his uncle, Jerome Lanier, was also active as a collector or dealer, and a less common six-pointed star mark (seen on pl. 11), often accompanied by the inscription 'Jerom', seems to be his.

However, the Laniers were not in the same league as the Earl of Arundel, who was at that time assembling Europe's finest collection of drawings. Arundel acquired the album containing 600 drawings by Leonardo da Vinci that was later to enter the Royal Collection (pl. 9) and many drawings by other, mainly Italian, artists such as Parmigianino. On the outbreak of the Civil War in 1642, Arundel left England, apparently taking much of his collection with him to the Low Countries. He died in Padua four years later, and the immediate fate of his collection of drawings is unknown.

Left: Fig. 7
POLIDORO DA CARAVAGGIO
(c.1499–1543)
Putti Pulling in a Net,
c.1527-8
Oil on panel,
29.8 x 141 cm

The Commonwealth Sale

In January 1642, some months before the outbreak of the Civil War, Charles I was obliged to flee London, leaving much of his collection behind. During the Civil War there were only isolated cases of destruction, such as damage to St George's Chapel, Windsor, and after the war the disposal of Charles I's collection was handled in an orderly manner. The House of Commons commissioned an inventory on 17 January 1649, a fortnight before the King's execution, and resolved to sell the entire collection. The money thus realised was to pay off the debts of the royal family and 'for public uses of this Commonwealth'.

The 'Commonwealth Sale' was conducted openly and with little public protest: it took place at Somerset House from October 1649 to late 1651, though some items were still being sold as late as 1653. The inventories of these sales provide the first complete record of Charles I's possessions, even if the entries vary in quality and detail.

About 1,570 pictures were valued at a total of £37,000, with the *Madonna della Perla* commanding the highest price (£2,000). The sale was delayed while the Council selected goods to be reserved for the use of the Protector, Oliver Cromwell, and the State, amongst which were Mantegna's *Triumphs of Caesar* (valued at £1,000), Raphael's tapestry cartoons (£300) and Gentileschi's Greenwich ceiling.

The first £30,000 raised was to be paid to the Treasurer of the Navy for the use of the fleet, then to the King's remaining retinue. A list of those with the most pressing needs was drawn up and £12,800 was dispensed to them. Those to whom small amounts were owed were paid in full and those owed larger amounts were partly paid in goods, including paintings, rather than cash. A second list was drawn up of creditors prepared to accept goods in lieu of payment.

A substantial number of the best Italian pictures passed out of English hands to new foreign owners, including Philip IV of Spain (paintings now

in the Prado), the Archduke Leopold Wilhelm, Governor of the Spanish Netherlands (now in the Kunsthistorisches Museum, Vienna), and the German banker Everard Jabach, who later sold his paintings to Louis XIV of France (now in the Louvre).

The Restoration

At the Restoration, Charles II (r. 1660–85, fig. 8) needed paintings to furnish his palaces and to re-establish some of the prestige surrounding the monarchy that his father had built up through his art collection. A committee was appointed the day after the proclamation of the Restoration, and almost as much energy was put into retrieving the Royal Collection as had been put into dispersing it.

Among the paintings recovered were Bronzino's *Portrait of a Lady in Green* (pl. 6), Dosso Dossi's *Holy Family* (pl. 24), Correggio's *Holy Family with St Jerome* (pl. 26), Bassano's *Adoration of the Shepherds* (pl. 40), and Tintoretto's *Esther before Ahasuerus* (pl. 56) and *The Muses* (pl. 57). Viscount Lisle, 3rd Earl of Leicester, who had acquired 120 works of art at the Commonwealth Sale, had to hand back a large group of paintings, including Caracciolo's *Cupid Sleeping* (pl. 72), Bassano's *Journey of Jacob* (pl. 53) and Fetti's *David with the Head of Goliath* (pl.71).

Charles II also made new acquisitions to fill the gap left by the Commonwealth Sale. In 1660 the states of Holland and West Friesland presented 24 paintings and 12 antique sculptures, bought from Gerard Reynst's widow for 80,000 guilders, to the King as he set off from Scheveningen to take the English throne. The so-called 'Dutch Gift' was made up predominantly of Italian sixteenth-century paintings, almost all of which were bought from the collection assembled by Jan Reynst and his brother Gerard.

While in exile Charles II had bought from William Frizell 72 paintings – Italian, Flemish, Dutch and German – at a cost of £2,686, which were sent

Fig. 8
**JOHN MICHAEL WRIGHT
(1617–1694)**
*Charles II, c.*1661–7 (detail)
Oil on canvas,
281.9 x 239.2 cm

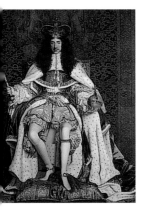

to England in 1662 after the Restoration. The finest works are the French and Netherlandish paintings, once in the collection of Rudolf II, which Frizell had acquired from Queen Christina of Sweden. There was also a small group of Italian pictures, including two paintings by Veronese, *David Victorious over Goliath* and *Judith with the Head of Holofernes*.

Charles II shared his father's taste: his preference was for Italian sixteenth-century painting, but he also admired the Dutch and Netherlandish masters. However, he seems to have lacked Charles I's intellectual passion for painting, and he had to be dissuaded by his treasurer, the Earl of Danby, from selling the Raphael cartoons to Louis XIV.

The inventories of Whitehall and Hampton Court Palaces drawn up around 1666–7 detail an impressive display of paintings in a similar combination of portraits and religious and secular art to that devised by Charles I. Nevertheless, Charles II admitted to a visitor rather sadly that the Cabinet Room was 'not half of what his father had owned'.

There were some seventeenth-century Italian paintings in the group bought from Frizell, but they are hard to identify. Sir John Finch, English Resident at Florence, commissioned Carlo Dolci to paint *Salome with the Head of John the Baptist* (pl. 84) for the King, and two religious subjects for his Catholic Queen, Catherine of Braganza. The King's mother, Henrietta Maria, had taken several paintings to Colombes near Paris, including Gentileschi's *Joseph and Potiphar's Wife* (fig. 6). All were retrieved when she died in 1669.

Cardinal Barberini was again in a position of influence and began sending gifts to the English Crown aimed at the Catholic Duke of York, the future James II (r. 1685–8). Two large mythological paintings by Giovanni Romanelli sent at the Restoration were to be seen at Hampton Court in 1681. Domenichino's *St Agnes* (pl. 76) is first recorded in 1663, when it hung in the Duke of York's Bedchamber at St James's Palace.

Charles also followed his father's lead in trying to persuade Italian artists to work in England: Benedetto Gennari worked in London for 15 years,

painting erotic mythological subjects for the King. The greatest contribution to the interior decoration of the period was made by Antonio Verrio, who created illusionistic murals for sequences of rooms at Windsor Castle (executed 1675–*c.*1684; three ceilings survive) and Hampton Court (executed *c.*1700–2; the King's Staircase and Queen's Drawing Room still remain).

Charles II's Collection of Drawings

Charles II was the first English monarch who seems to have had a genuine interest in drawings. By 1675 he had somehow reacquired the album of Holbeins exchanged by his father almost fifty years earlier. Three years later 'Carlo Stuart' was listed among those who owned drawings by the Carracci. However, there is little documentation from the period to explain how Charles II formed his collection of drawings, and we have to rely on physical evidence and later sources for the small amount of information we do have.

In 1690 Constantijn Huygens, the Dutch secretary to King William III, made several entries in his diary describing drawings by Holbein, Leonardo da Vinci and Parmigianino that he had seen at Whitehall Palace. This is the first reference to the Leonardo album being in the Royal Collection, and we have no record of what had happened to it since it had been in Arundel's collection half a century before.

It seems certain that all the drawings mentioned by Huygens had been in the Royal Collection since the reign of Charles II, and that William and Mary had simply come into possession of them when James II fled England. The identity of some of the drawings – beyond the Holbeins, Leonardos and Parmigianinos – may be established from physical evidence, for many Italian Renaissance drawings now in the Royal Collection bear marks indicating that they were in England in the seventeenth century – those star-shaped stamps and inscriptions associated with Nicholas and Jerome Lanier, found on 40 drawings; the price marks of the dealer William Gibson, added to the reverses

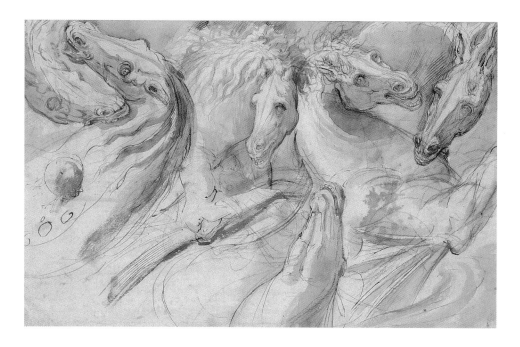

of another 51 (including fig. 9 and pl. 63); the inscribed attributions of another neat but unidentified late seventeenth-century hand; and the clipped top corners that seems to have been a fashionable method of shaping drawings for mounting in England at that time. However, as the majority of seventeenth-century dealers and collectors left no mark on their drawings, the provenance of many of Charles II's drawings is likely to remain unknown.

The Glorious Revolution

On the day that William III (r. 1689–1704) and Mary II (r. 1689–94) were jointly offered the Crown, William discussed the paintings at Whitehall with Huygens. Although William added little to the contents of the collection, he was very interested in its arrangement and display.

One of the fortunate consequences of William III's purchase of Kensington Palace in 1689 was that he moved the contents of the Whitehall Cabinet Room there, and thus they escaped the fire that destroyed Whitehall Palace in 1698. He built a new King's Gallery and arranged a dense hang of paintings, including such impressive Italian examples as the two large Tintorettos, *Esther before Ahasuerus* (pl. 56) and *The Muses* (pl. 57), and Schiavone's *Judgement of Midas* (pl. 54).

As part of William's rebuilding of Hampton Court, Mantegna's *Triumphs of Caesar* were moved from the King's Gallery to the 'Green Gallery' (now called the Queen's Gallery). The Raphael cartoons were reassembled, mounted on canvas and displayed in the King's Gallery, which was remodelled by Christopher Wren and William Talman. William III chose small-scale Italian and Dutch paintings for his private apartments, including the two panels by Giulio Romano of *An Emperor on Horseback* (pl. 31) in an arrangement that was reconstructed in the 1980s and can still be enjoyed today.

George I, George II and Frederick, Prince of Wales

Between 1725 and 1727 George I (r. 1714–27) commissioned William Kent to remodel the King's Gallery in Kensington Palace: this involved rehanging the pictures and reframing them in carved and gilded 'Palladian' frames by John Howard that related to the architectural scheme as a whole.

The 'extreme ignorance in painting' exhibited by George II (r. 1727–60) contrasted with his wife's appreciation of art. Queen Caroline bought several Italian works of art, including Vasari's *Venus and Cupid* in 1734 for £1,000. William Hogarth dismissed it as a 'monstrous Venus at Kensington'.

From an early age George II's son, Frederick, Prince of Wales (fig. 10), admired and collected sixteenth- and seventeeth-century paintings by Italian, Flemish, Dutch and French masters. His taste was in part driven by a

Fig. 10
JACOPO AMIGONI
(1707–1751)
Frederick, Prince of Wales, 1735
Oil on canvas,
128.3 x 106,7 cm

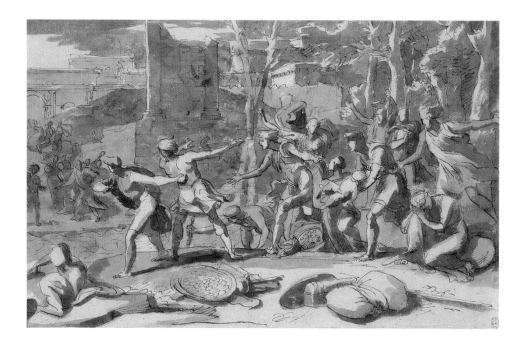

Fig. 11
NICOLAS POUSSIN
(1594–1665)
The Saving of the Infant Pyrrhus, c.1633–4
Pen and ink with brown wash over red chalk, 20.6 x 34.5 cm
(see pl. 100)

desire to emulate Charles I as a collector and connoisseur.

Frederick had various advisers, including Major-General John Guise and his 'Cabinet Painter', Joseph Goupy. It was probably Goupy who painted a set of copies of Luca Giordano's *Story of Cupid and Psyche* series, before Frederick's son, George III, acquired the originals (pls 85–88).

The Prince also bought from the sale room, where he acquired two Andrea del Sartos from the collection of the French writer Roger de Piles, and from dealers such as Mr Edwins. Cagnacci's *Jacob Peeling the Rods* was probably a gift from Lord Malpas, later Lord Cholmondely, Master of the Horse to the Prince. Frederick's most significant acquisition of drawings – an album by Nicolas Poussin (fig. 11) – was probably a gift from Dr Richard Mead, the royal physician.

In 1749 the Prince employed the antiquarian George Vertue to catalogue

his collection at his various residences (Carlton House, Leicester House and Kew), including those works surviving from the old Royal Collection. Vertue particularly admired Reni's *Cleopatra with the Asp* (pl. 77), then at Leicester House. After Frederick's premature death in 1751, Vertue wrote, 'no Prince since King Charles the First took so much pleasure nor observations on works of art or artists'.

George III

Frederick's eldest son, George III (r. 1760–1820, fig. 12), showed a similar aptitude for the fine arts. In 1755, five years before he succeeded his grandfather, George II, he engaged Richard Dalton as his Librarian under the eye of his mentor, the Earl of Bute. It seems that Bute was almost entirely responsible for influencing the young George's taste in old master drawings: Dalton's role was apparently less to organise the Prince's library than to act as his agent in the acquisition of works of art.

Fig. 12
JOHAN ZOFFANY
(1733–1810)
George III, 1761–2 (detail)
Oil on canvas,
163.2 x 137.3cm

In May 1758 Dalton set out for Italy to buy works of art for the Prince (and for Bute and Sir Richard Grosvenor). His first consignment of drawings for the Prince of Wales, including a Raphael, about 40 Guercinos and several Carraccis, was dispatched from Livorno in late February 1759. Dalton made several visits to Italy, during which he acquired most or all of the remainder of the 836 drawings from Guercino's studio now at Windsor (pls 90, 98), as well as 60 drawings by Sassoferrato (pl. 102), bought by Dalton for the modest sum of 20 *scudi* (£5).

It is likely that Dalton also purchased, in 1763, *The Libyan Sibyl* (pl. 83), an example of Guercino's late work, and Gennari's copy of Guercino's *Self-portrait* in Bologna, as well as Annibale Carracci's

Madonna and Sleeping Child with the Infant St John the Baptist ('Il *Silenzio*', pl. 67). This strong and deceptively simple composition was probably bought from the Farnese family. George III paid Dalton £262 for it and hung it in the King's Closet in Buckingham House, the new royal residence in London, purchased in 1762.

Hoping to be awarded the Order of the Garter, George, 3rd Earl Cowper, who lived in Florence, offered Raphael's Niccolini-Cowper *Virgin and Child* and a painting believed to be an early Raphael self-portrait to George III for £2,500 in 1780. The Niccolini-Cowper *Virgin and Child* was not acquired and is now in the National Gallery of Art, Washington, DC, but the portrait (pl. 4) was given to the King and was hanging in the Queen's Dining Room, Kensington, by 1785.

The two most spectacular acquisitions of George III's reign were the collections of Joseph Smith and Cardinal Alessandro Albani. Joseph Smith had lived in Venice as a merchant banker since around 1700 and had been appointed British Consul there in 1744. He was a friend and patron of many leading artists in the city, forming an extensive collection of their works in addition to a fine group of paintings and drawings by old masters. However, Smith fell into financial difficulties during the War of the Austrian Succession (1740–8) and the Seven Years' War (1756–63), and was forced to sell his collection, including his huge library. By July 1762 George III had agreed a sum of £20,000, and the following winter Dalton travelled to Venice to oversee the packing and transport of Smith's collection.

George III acquired about 500 paintings from Consul Smith, of which two-thirds were by Italian artists. Most of the latter were by Venetian eighteenth-century masters, such as Canaletto, Sebastiano and Marco Ricci, Antonio Visentini and Anton Maria Zanetti, but some important earlier Italian paintings were also included. Among these were an album of drawings by Giovanni Ambrogio Figino, four volumes by Giovanni Benedetto Castiglione (pls 105, 107) and a number of previously framed drawings, including Ludovico Carracci's *Martyrdom of St Ursula* (pl. 97).

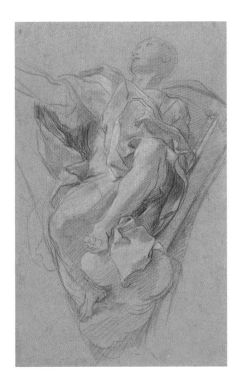

Fig. 13
CARLO MARATTI
(1625–1713)
*A Study for the Prophet
Balaam*, c.1683–4
Red and white chalks on
blue paper, 41.9 x 26.7 cm

Maratti was commissioned
during the 1670s to paint a
series of canvases as
models for mosaics in the
vault of the Cappella della
Presentazione in St Peter's.
This is a study for the
prophet Balaam, for one of
the triangular pendentives.

No proper inventory of the items included in
the purchase survives. There are early nineteenth-
century lists of paintings in the Royal Collection
arranged by school, but they do not record
provenances. However, Giovanni Bellini's *Portrait
of a Young Man* (pl. 41), his last surviving portrait,
Bernardo Strozzi's *Concert* (pl. 81), Leandro
Bassano's *Tiziano Aspetti* (pl. 55) and Turchi's
four organ shutters (pl. 75) are all works that
certainly entered the Royal Collection as part of
the Smith purchase.

George III's other great purchase was the
collection of drawings of Cardinal Albani in 1762
for 14,000 *scudi* (£3,500). As a young man Albani
had acquired a huge number of drawings from his
uncle, Pope Clement XI, including the collections
of Carlo Maratti, the leading exponent of classicism
in late Baroque Rome (fig. 13, pl. 110); and of
Cassiano dal Pozzo, one of the great figures of early
seventeenth-century Rome, who had commissioned
many thousands of drawings and prints to form a visual encyclopaedia or
'Paper Museum', principally of antiquities, architecture and natural history
(fig. 14).

Again, no inventory of the Albani collection survives, and while we can
state that some groups of drawings come from that source with certainty, and
others with reasonable confidence (such as those by Sacchi and Lanfranco),
we have no firm evidence for the acquisition of several important groups of
seventeenth-century Roman drawings, such as those by Maratti (aside from
those from his collection) and Bernini.

A small number of albums from the Smith and Albani collections remain
intact, but many of the drawings that George III purchased or inherited were

remounted with characteristic wash borders in the King's bindery, rearranged by artist and school, and placed within new albums, thus obliterating much physical evidence of their earlier provenance. The arrangement of the collection towards the end of George III's reign was recorded in the so-called 'Inventory A', the earliest detailed inventory of the Royal Collection of drawings, compiled (partly from earlier lists) around 1810 and describing, in varying degrees of detail, the contents of the many albums then kept in the Library of Buckingham House.

In spite of these magnificent acquisitions, we are left with the impression that George III lacked the zeal for collecting art that his father and son both had. He took a more down-to-earth approach, acquiring paintings in order to furnish Buckingham House, and drawings (like books) to fill his library. New acquisitions were combined with inherited and contemporary paintings. In his time, the King's Closet was densely hung with sixteenth-century Italian paintings, complementing the seventeenth-century works, which included Guercino's *Libyan Sibyl*, Reni's *Cleopatra* and Annibale Carracci's *Il Silenzio*. The Turchi organ shutters were part of a hang of twenty Venetian pictures in the King's Library. Upstairs the Raphael cartoons were brought from Hampton Court and hung in the Great Room (or Saloon).

George IV

In spite of his importance as a collector in almost every other area, George III's son George IV (r. 1820–30) made a negligible contribution to the Italian holdings of the Royal Collection. When in 1823 he donated his father's library to the British Museum, the albums of drawings were clearly seen as distinct from the collection of books and were retained, though the King had little personal interest in old master drawings.

In 1830 George IV was offered the collection of Sir Thomas Lawrence, one of the greatest collections of old master drawings ever formed by one man, for £18,000, well below the market price. However, with his health failing at the end of his life, the King did not take the opportunity to purchase it. Had he been able to accept, the Royal Collection would now hold the world's greatest group of drawings by Michelangelo and Raphael alongside those by Leonardo.

Fig. 15
SIR EDWIN LANDSEER
(1803–1873)
*Queen Victoria and
Prince Albert at the Bal
Costumé of 12 May 1842,*
1842–6 (detail)
Oil on canvas,
143 x 111.6 cm

Queen Victoria and Prince Albert

Prince Albert was the only royal collector to have travelled extensively in Italy. His visit as a young man from 1838 to 1839 awakened his love of early Florentine painting. In Rome he met his future artistic adviser, Ludwig Grüner, and possibly some painters from the group called the 'Nazarenes'. After his marriage to Queen Victoria (r. 1837–1901, fig. 15) in 1840, he concerned himself with the care of the paintings, particularly those at Hampton Court, and commissioned Richard Redgrave's descriptive inventory of the entire Royal Collection.

The royal couple's acquisition of early Italian, German and Netherlandish pictures (many bought as presents for each other) make up the last significant addition to the old master holdings of the Royal Collection. All but a handful date from the fourteenth and fifteenth centuries, bought at a time when such works were still regarded as 'primitive'.

The only Victorian acquisition in this book is Romanino's *Portrait of a Man* (fig. 16), bought in May 1846 as a Giorgione and hung (with much of Albert's early Italian collection) in the Dressing Room and Writing Room at Osborne House (itself inspired by Italian Renaissance architecture). One of Romanino's earliest portraits, it shows the influence of Giorgione and Titian in the softly modelled face and fine hair of the moustache, which contrast with the rich and varied textures of the clothes.

In 1851 Prince Albert acquired a collection of early Italian, German and Netherlandish pictures belonging to his cousin, Prince Louis (Ludwig) of Oettingen-Wallerstein, as security for a loan of £3,000 that was never repaid. Queen Victoria gave the best of this group to the National Gallery, London in 1863, after the Prince Consort's death. In 1865, the Queen offered the Raphael cartoons on long-term loan to the newly founded South Kensington Museum (later renamed the Victoria and Albert Museum) in London, where they have remained ever since.

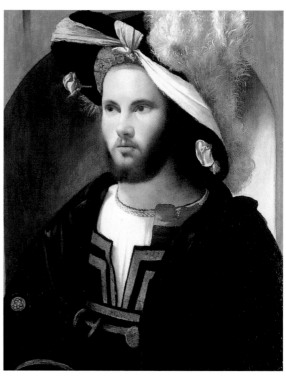

Fig. 16
GIROLAMO ROMANINO
(c.1484/7–c.1560)
Portrait of a Man, c.1515–17
Oil on panel, 82.1 x 68.9 cm
(see pl. 48)

Conclusion

The rich holdings of Italian art of the Renaissance and Baroque that we see today in the Royal Collection are in effect the legacy of the Stuarts. Many of the greatest paintings collected by Charles I could not be reclaimed by his son, but some major works were retrieved. More crucially, the memory of what was once in the Collection and an awareness of the importance of Italian art for Charles I were inherited by his successors. Subsequent royal collectors, such as Frederick, Prince of Wales, deliberately tried to match Charles I's example.

The way in which Italian art is represented in the Royal Collection has been determined by personal taste, as well as a desire to keep up to date with contemporary Italian art, either by collecting or encouraging Italian artists to work in this country. Paintings were displayed both to make a public show of magnificence and for more private enjoyment. In the seventeenth century Italian art served as 'a piece of State', part of grand plans for galleries or as pawns in political manoeuvres. But it also provided a cabinet for kings. It was for his private rooms at Osborne House that Prince Albert collected small, refined 'gold backs', while the collections at Hampton Court and Windsor Castle could now be viewed by the general public. Today Italian art in the Royal Collection is displayed in all its diverse locations, much of it available to be enjoyed and studied by visitors. Some of its greatest highlights are brought together in these pages.

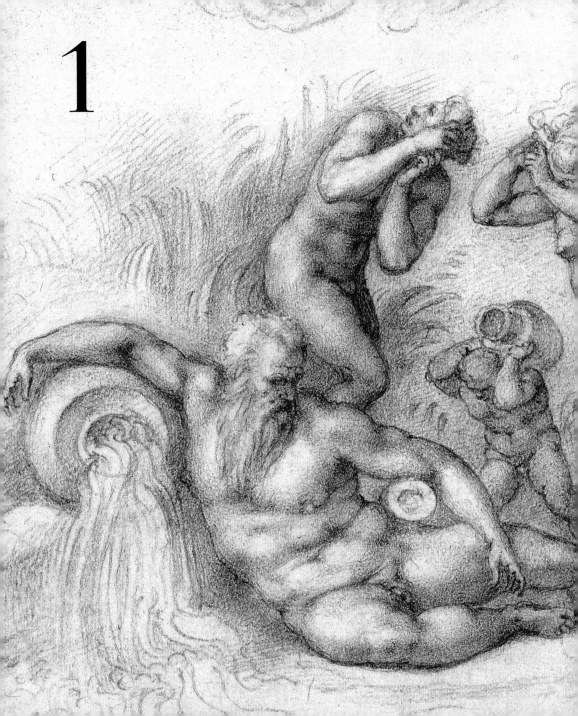

Left
1. ATTRIBUTED TO JACOPO DA PONTORMO
(1494–1556)
The Virgin and Child,
c.1534–40
Oil on panel, 122 x 102.2 cm

This is one of at least twenty-five versions of the subject associated with Pontormo and his followers, making it the most copied work of its time in Florence. The Virgin is seated on the ground holding an open book while the Christ Child looks up ecstatically. In the background, Joseph holds a saw and takes cherries (symbolising Heaven) from an older child, possibly St John the Baptist or Christ again. The older woman is either St Elizabeth, John's mother, or St Anne, the Virgin's mother. The figure on the stairs is probably a servant-girl. The technique, with such lucid definition of forms, suggests that this version is by Pontormo himself.

Previous pages
MICHELANGELO BUONARROTI (1475–1564)
The Fall of Phaeton
(see pl. 14)

Above
2. ANDREA DEL SARTO
(1486–1530)
The Virgin and Child,
c.1528–30
Oil on panel, 56.4 x 42.7 cm

Such an intimate painting must have been a devotional image intended for a domestic setting. It has a natural directness as the Virgin seems to be firmly but gently holding down the Christ Child's lower lip and searching for signs of teeth. The first of several versions, the painting is exploratory and unfinished.

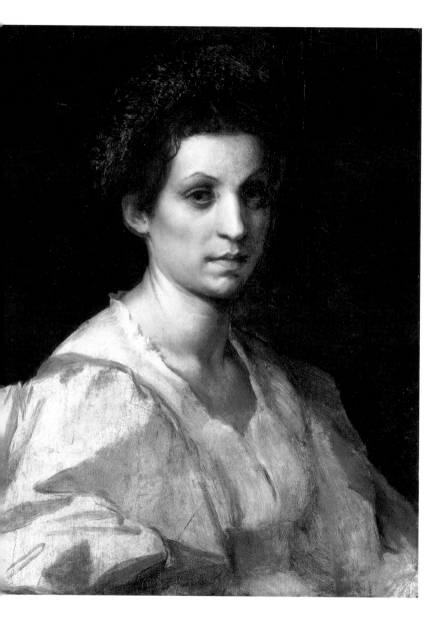

Left
3. ANDREA DEL SARTO
(1486–1530)
Portrait of a Woman in Yellow, c.1529–30
Oil on panel, 64.3 x 50.1 cm

The unknown sitter appears enigmatic in this unfinished portrait which dates from the very end of Sarto's life: it is possible that his death from the plague prevented its completion. The highly polished skin tones of the face contrast with the spontaneity of her broadly painted dress, which has in places been adjusted with the artist's palm and fingers. The way the sitter emerges from the dark background is typical of Sarto's late work.

Right
4. FOLLOWER OF RAPHAEL
(1483–1520)
Portrait of a Man,
c.1506–13
Oil on panel, 42.8 x 41.9 cm

This portrait raises two intriguing questions: is it by Raphael, and does it represent Raphael? The apparently original inscriptions on the eyelets of the cloak read 'RAFFAELLO' and 'URBINUS'. However it is not clear if they are intended to refer to the artist or the sitter. The portrait may be a pastiche by an artist who knew Raphael's work well, or possibly an early copy of a lost original.

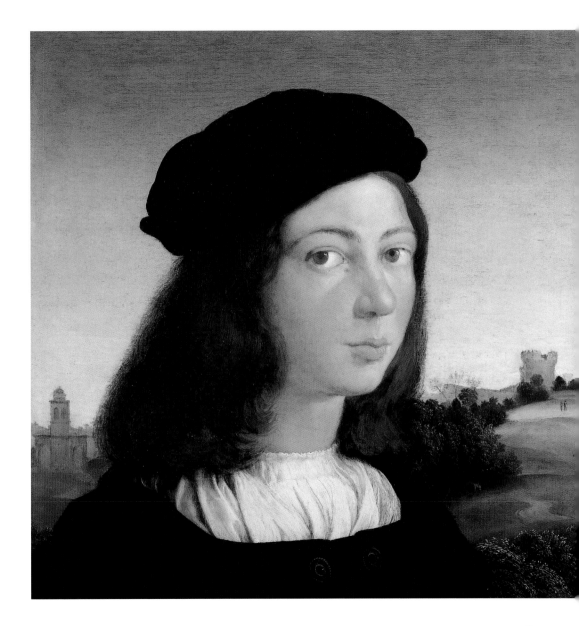

Previous pages
5. POLIDORO DA CARAVAGGIO
(C.1499–C.1543)
*Psyche Exposed on a Rock, c.*1527–8
Oil on panel, 85.7 x 161.5 cm

One of a series, made up of three large scenes from the love story of Cupid and Psyche and six ornamental friezes. The amorous subject matter may suggest that the paintings were part of the decoration of a bedroom. It is possible that they formed a frieze around the wall just below the ceiling and that the larger scenes were either set below them or in the ceiling.

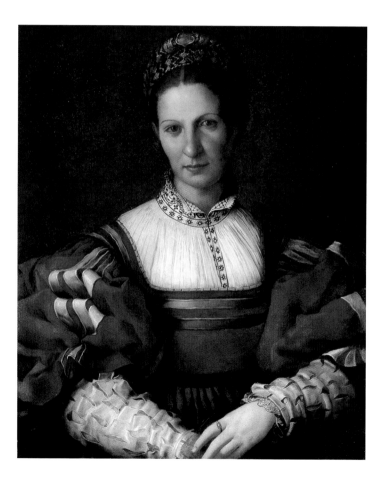

Left and right
6. AGNOLO BRONZINO
(1503–1572)
*Portrait of a Lady in Green, c.*1528–32
Oil on panel,
76.6. x 66.2 cm

The identities of both the artist and sitter in this portrait have often been debated. It appears to date from early in Bronzino's career when he was strongly influenced by his master Pontormo. The direct gaze, deceptively simple pose and precision of technique are typical of Bronzino's portraits. The sitter may be a daughter of Matteo Sofferoni, a member of the same artistic and literary circle as Bronzino and Pontormo.

**7. Francesco Salviati
(1510–1563)**
*The Virgin and Child
with an Angel, c.*1538–40
Oil on panel, 112.3 x 84.5 cm

This painting exemplifies
the combination of realism,
artificiality and powerful
elegance typical of Salviati's
works. The Virgin looks
away from the sleeping
Christ Child, while an angel
gazes down at him through
a transparent veil, just
visible between his fingers.
The angel may foresee the
future Passion of Christ,
whose sleeping pose
reminds us of his death
and entombment.

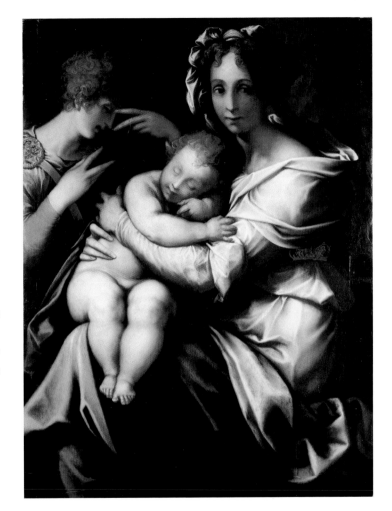

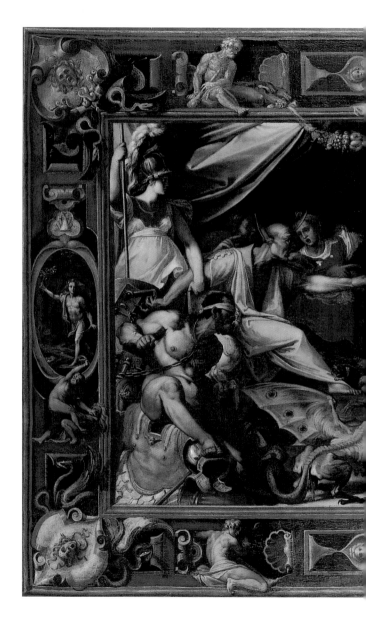

**8. FEDERICO ZUCCARO
(C.1540/42–1609)**
Calumny, *c.*1569–72
Oil on canvas,
144.6 x 235 cm

Federico painted this
allegory as a response to
his dismissal by Cardinal
Alessandro Farnese in 1569
and to promote his ideas
about painting. It is an
adaptation of the world's
most famous lost picture:
the *Calumny* by the 4th
century B.C. Greek artist
Apelles, which was descri-
bed by Lucian. Vices are
turning King Midas (on
the left) against the inno-
cent 'hero' (on the right).
However, in contrast to
the original story, there is
a happy ending: the hero
is led to safety by Mercury
and a nude woman repre-
senting Purity.

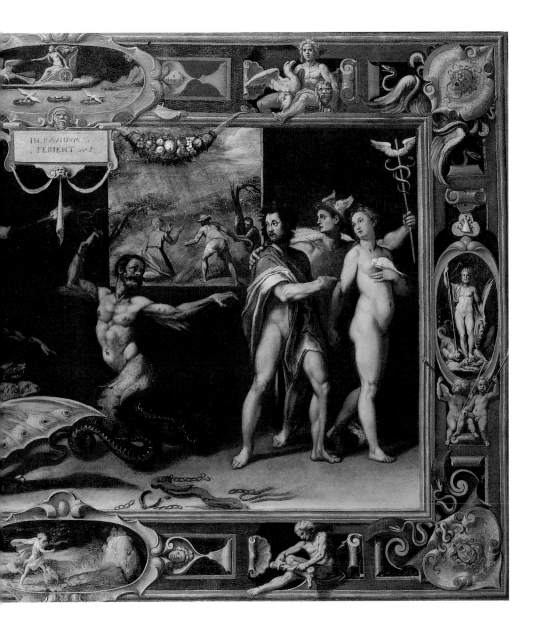

IN PAVIDVM
FERIENT

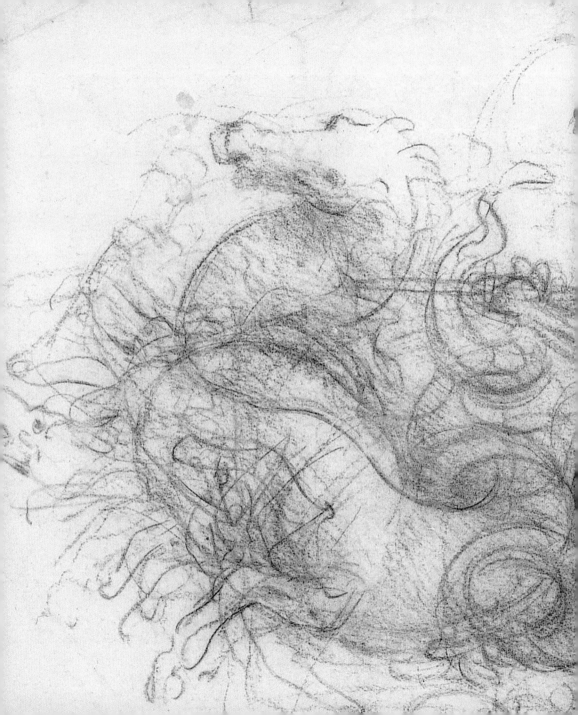

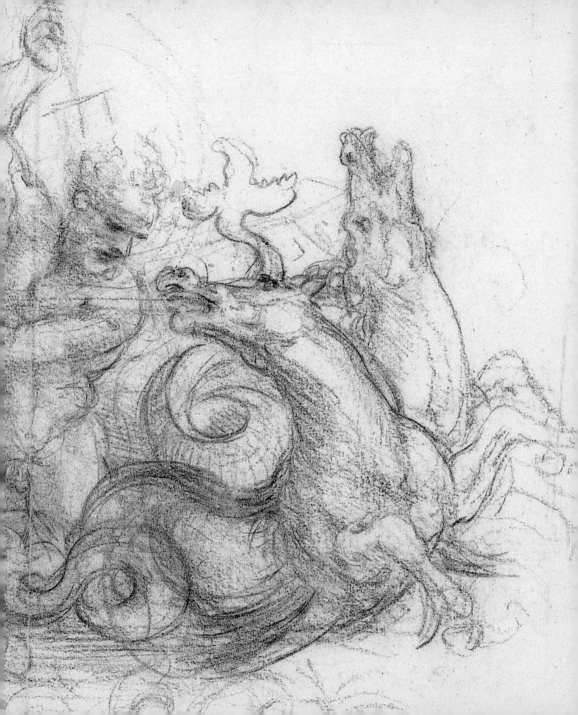

Previous pages
**9. LEONARDO DA VINCI
(1452–1519)**
Neptune, c.1504
Black chalk, 25.1 x 39.2 cm

Leonardo spent most of the period 1500-08 in Florence. Among many other works, he executed a large finished drawing of Neptune for his friend Antonio Segni, master of the papal mint. That drawing was celebrated

during the sixteenth century but is now lost, and we have no certain knowledge of its appearance beyond this sketch for the composition, which carries Leonardo's rough note to himself to 'lower the horses'.

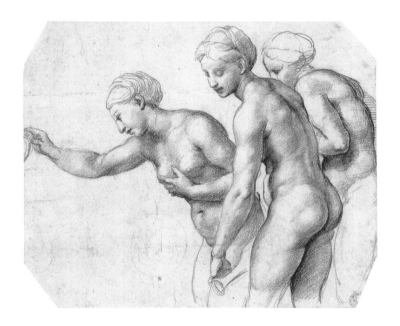

Above and right
10. RAPHAEL (1483–1520)
The Three Graces, c.1517–18
Red chalk over some stylus underdrawing, 20.3 x 25.8 cm, the corners cut

Around 1517 Raphael's assistants frescoed the vault of the garden loggia of Agostino Chigi's villa in Rome, now known as the Villa Farnesina. This is a study, from a single model in three consecutive poses, for

the Three Graces pouring a libation in the *Wedding Feast of Cupid and Psyche*. Though Raphael executed none of the frescoes himself, drawings such as this show that he was closely involved in their design.

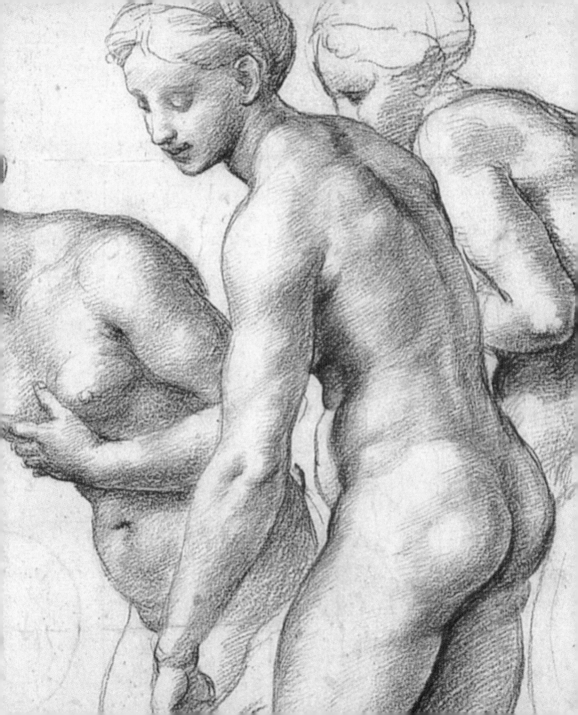

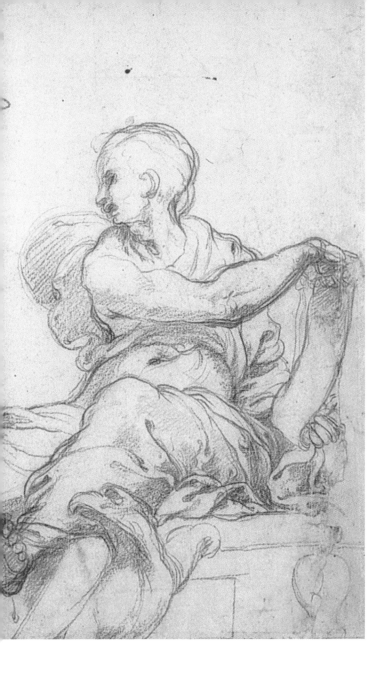

**11. PERINO DEL VAGA
(1501–1547)**
*St Mark and St John
with Putti, c.1525*
Red chalk over squaring
with the stylus,
32.7 x 51.2 cm

Perino del Vaga worked
for a time under Raphael,
and during the 1520s
established himself as one
of Rome's leading fresco
painters. This is a study
for two of the Evangelists –
St Mark with his lion, and
St John with his eagle –
painted by Perino in the
vault of a chapel in San
Marcello al Corso. The
project was interrupted by
the Sack of Rome in 1527
and was completed (by
Perino's assistant Daniele
da Volterra) only in 1543.

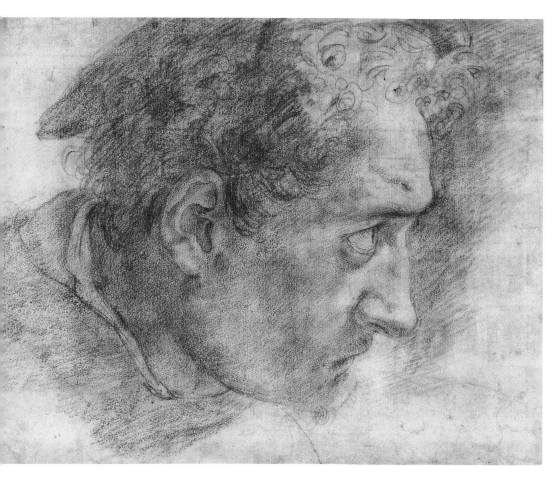

Above
12. POLIDORO DA CARAVAGGIO
(C.1499–C.1543)
Head of St Thomas, *c.*1527
Red chalk, 20.9 x 26.8 cm

Polidoro da Caravaggio produced some of the most engaging life studies of the Renaissance. The figure here has been given a halo, and looks up with an expression of trepidation; he might be St Thomas at the moment at which Christ showed his wound to the incredulous Disciple after the Resurrection. Polidoro executed a painting of that subject around 1530 (now in the Courtauld Institute Galleries), but the saint there is quite different in appearance.

Right
13. BACCIO BANDINELLI
(1488–1560)
Head of a Man, *c.*1545
(detail)
Pen and ink, 40 x 26.5 cm

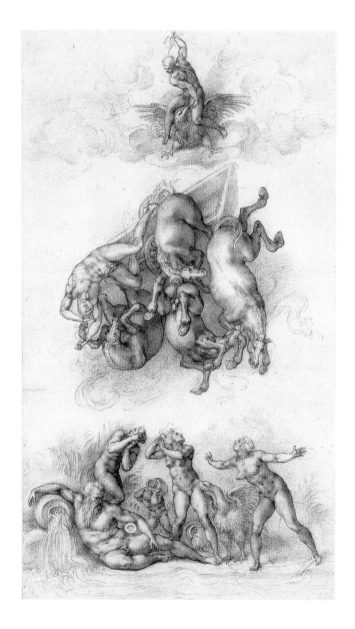

14. MICHELANGELO BUONARROTI (1475–1564)
The Fall of Phaeton, 1533
Black chalk, 41.3 x 23.4 cm

Michelangelo befriended the young nobleman Tommaso de' Cavalieri in 1532. Over the next year he made four highly finished drawings as gifts for Cavalieri, including this one and pl. 15. This sheet depicts the myth of Phaeton, who begged his father Apollo to be allowed to drive the sun-chariot for a day. Phaeton lost control of the chariot, and had to be knocked from the sky by a thunderbolt from Jupiter.

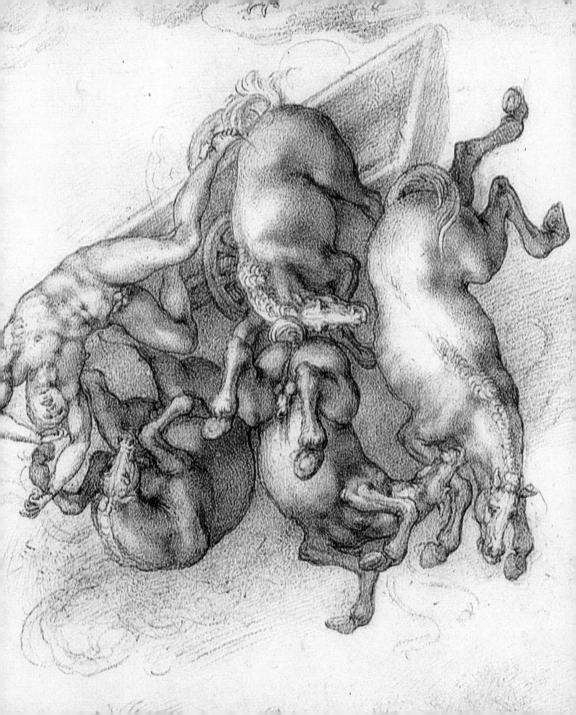

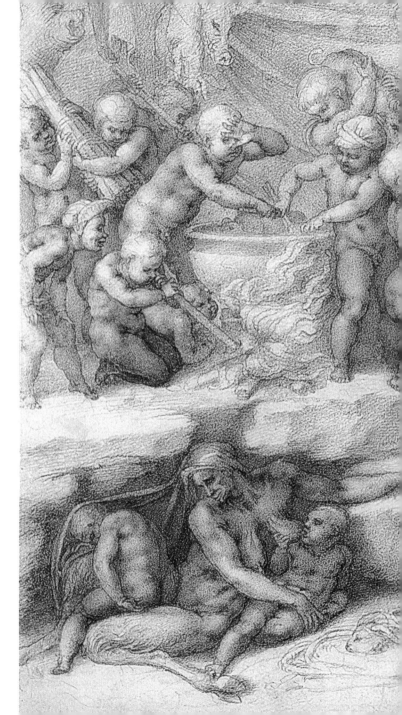

15. MICHELANGELO BUONARROTI (1475–1564)
A Children's Bacchanal, 1533
Red chalk, 27.4 x 38.8 cm

Like the *Fall of Phaeton* (pl. 14), this 'presentation drawing' was executed by Michelangelo as a gift for Tommaso de' Cavalieri. The level of finish is extraordinary, even by Michelangelo's standards, and the sheet is almost perfectly preserved. The children represent the lowest state of humanity, devoid of reason (also denoted by the drunken slumber of the only adult human) and acting in a semi-animal manner, made explicit by the satyress suckling at lower left.

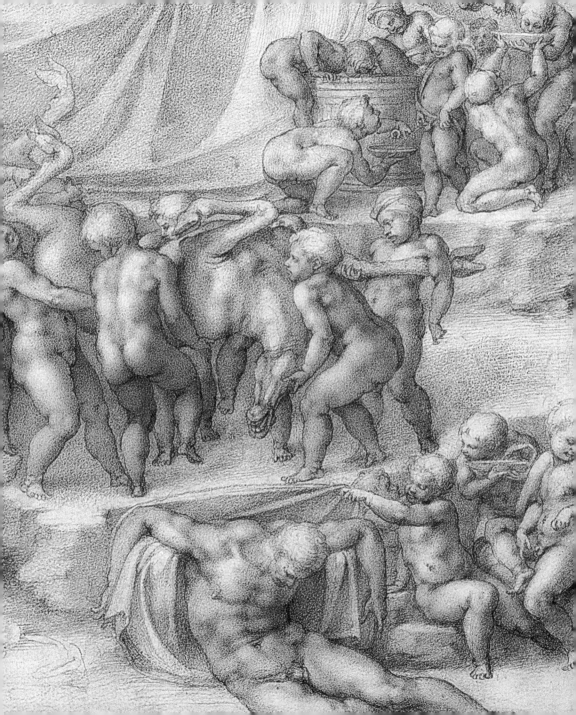

Left
16. GIOVANNI STRADANUS
(1523–1605)
Odysseus and Circe, 1570
(detail)
Pen and ink with wash and
white heightening over black
chalk underdrawing, on
paper washed yellow,
29.9 x 22 cm

Jan van der Straet travelled as
a young man from Flanders
to Italy (where he adopted the
name Giovanni Stradanus),
and spent most of his career
in Florence. This is a study
for a painting in Francesco
de' Medici's cabinet room
or *studiolo* in the Palazzo
Vecchio. After the Trojan War,
Odysseus landed on the
island of the sorceress Circe,
who turned his companions
into animals. Odysseus set
out to Circe's palace to free
the men, protected by a herb
given to him by Mercury,
here at lower left.

Right
17. PARIS NOGARI
(c.1536–1601)
The Circumcision, c.1580
Pen and ink with wash and
white heightening, over
black chalk, on blue paper,
41.7 x 24.6 cm

This is a study for Nogari's
painting of the *Circumcision
of Christ* in the church of
Santo Spirito in Sassia,
Rome. The scene is depicted
as if from below. Nogari
adopted many of the devices
typical of late Roman
Mannerism – half-length
figures cut off by the bottom
of the frame, for example.

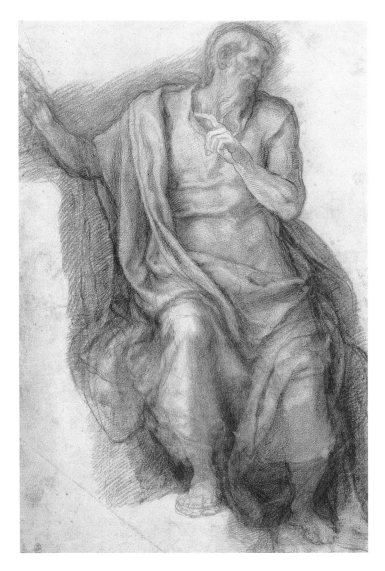

**18. GIROLAMO MUZIANO
(1532–1592)**
St Jerome, c.1580
Red chalk, partly washed
over, 39 x 27.6 cm

The drawing is a study for
Muziano's altarpiece of
*St Jerome Preaching in the
Wilderness*, painted for
St Peter's, Rome, and
later transferred to Santa
Maria degli Angeli. The
pose is based on that
of the prophet Ezekiel in
Michelangelo's Sistine
ceiling, but the heavy
figure and clinging drapery
emulate Michelangelo's
later style, as typified by his
frescoes of the 1540s in the
Pauline Chapel of the
Vatican.

Right
**19. LUDOVICO CIGOLI
(1559–1613)**
Two Servants, 1591 (detail)
Brush in ink and white on
grey-blue prepared paper,
40.3 x 24.6 cm

The drawing is executed
in Cigoli's distinctive
technique of broad brush
and ink on dark prepared
paper. It is a study for an
altarpiece of the *Emperor
Heraclitus carrying the True
Cross into Jerusalem*, painted
for the silk-weavers' guild
for their chapel in San
Marco, Florence. One of
the servants carries the
emperor's peaked hat
on a platter.

2

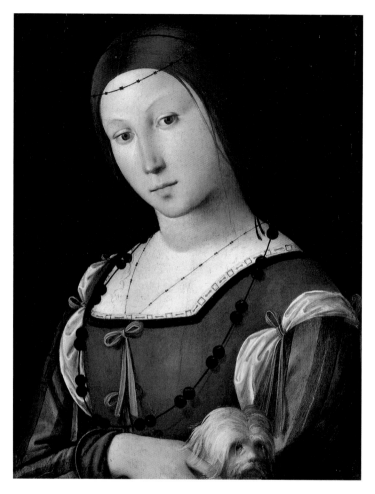

21. Lorenzo Costa
(c.1460–1535)
Portrait of a Lady with
*a Lap-dog, c.*1500–1505
Oil on panel, 45.4 x 35 cm

The sitter's costume, for example the detachable sleeves decorated with stripes and the band or *lenza* around the crown of her head, is typical of the north Italian courts from around 1490–1505. In 1508, Isabella d'Este sent two portraits by Costa – one of herself and one of her daughter Eleonora – to her husband Francesco Gonzaga, who was being held captive in Venice. However, as Eleonora was only about 11 at the time this portrait was painted, the sitter must be another young lady from the Bolognese or Mantuan courts.

Previous pages
20. Garofalo
(c.1476–1559)
The Holy Family, 1533
(detail)
Oil on panel,
42.5 x 55.4 cm

Garofalo combined his knowledge of Raphael and the antique with his Ferrarese training. The veiled old woman here is probably the Virgin's mother, St Anne. Her gesture links the written word, being read by the Virgin, with its embodiment, the Christ Child. The wounds on Christ's hands and feet foretell his Passion on the Cross; the stone beneath his foot alludes to his future tomb.

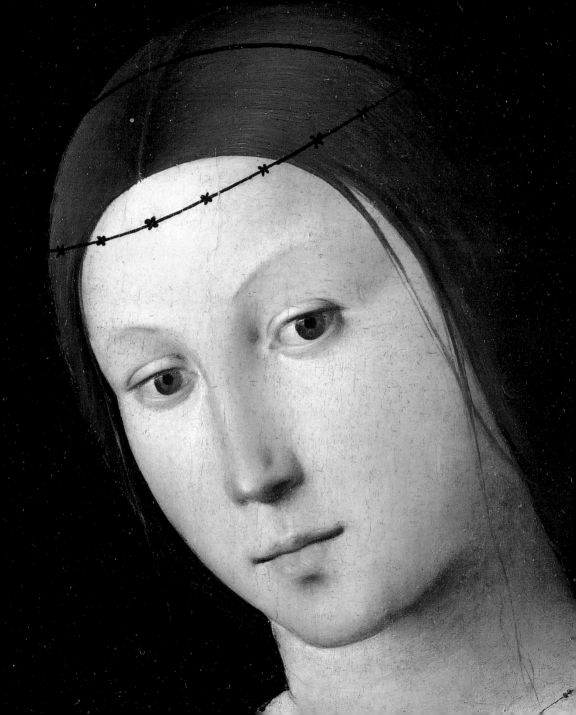

Left
22. Parmigianino
(1503–40)
Portrait of a Young
Nobleman, c.1530–32
Oil on panel, 98.5 x 82.4 cm

Above
23. Ludovico Mazzolino
(c.1480–c.1528)
Warriors, c.1522–6
Oil on panel, 24.8 x 25.4 cm

This is a fragment of a much larger painting by the Ferrarese artist Mazzolino. When the painting was conserved, the horses galloping away in the distance and more of the figures on the right were uncovered. The subject may be part of a *Crucifixion* or a *Way to Calvary*, or possibly a scene from the *Legend of the True Cross*, with Louis IX on a white horse with his emblem, the gold fleur-de-lys, receiving a fragment of the Cross.

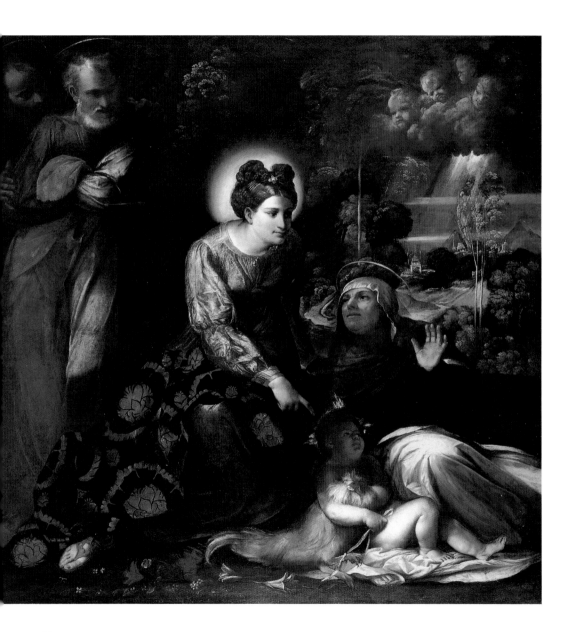

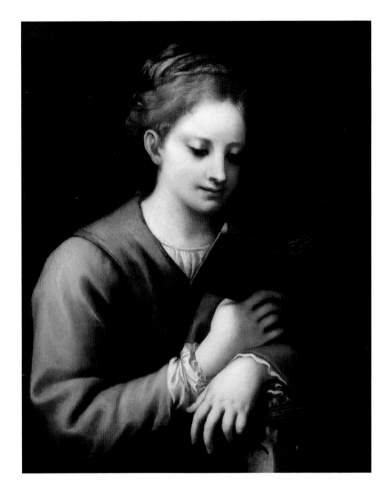

Left
24. Dosso Dossi
(c.1490–c.1541/2)
The Holy Family, c.1527–8
Oil on canvas,
169.7 x 172.7 cm

Though court artist to
the Este of Ferrara, Dosso
painted this for the
Gonzaga, rulers of nearby
Mantua. The painting
depicts the Holy Family
with probably the Virgin's
parents, St Joachim and
St Anne, in a dramatically
lit landscape. The cockerel
held by the Christ Child
alludes to his Resurrection
and the reawakening of the
world, as the cock crows to
mark the dawn of a new day.

Above
25. Correggio
(c.1489–1534)
St Catherine Reading,
c.1530–32
Oil on canvas,
64.5 x 52.2 cm

St Catherine of Alexandria
was desired by the Roman
Emperor Maxentius. She
refused to marry him or
renounce her Christian
faith. He ordered her to
be tortured to death on
a spiked wheel, but it

shattered miraculously;
she was finally beheaded.
Renowned for her learning,
in this late work by
Correggio she rests her
book on a fragment of
her wheel and holds a
martyr's palm.

**26. CORREGGIO
(c.1489–1534)**
*The Holy Family with
St Jerome, c.*1519
Oil on panel, 68.8 x 56.6 cm

This altarpiece is an early
work probably dating from
soon after Correggio left
his native town to settle in
Parma. The Virgin and Child
with Joseph on the right all
gaze at the figure on the left,

thought to be St Jerome,
who is blessed by the Christ
Child. This and *St Catherine
Reading* (pl. 25) are the
remaining two of the eight
works by Correggio once
owned by Charles I.

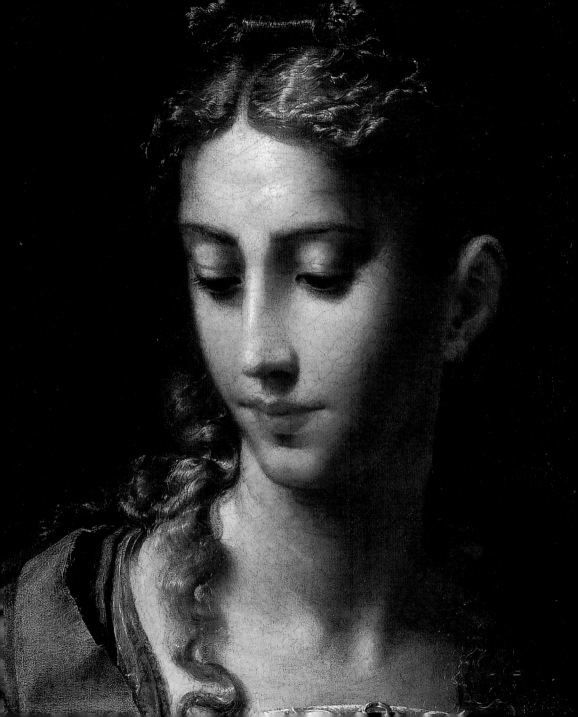

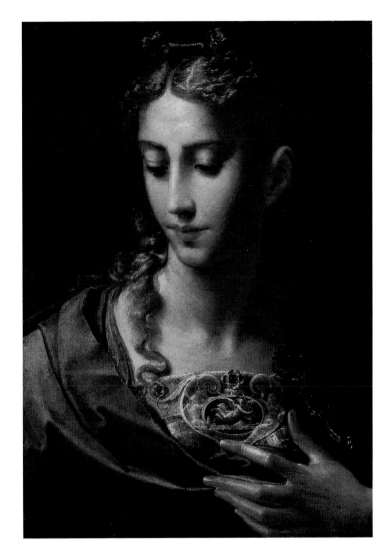

27. PARMIGIANINO
(1503–40)
*Pallas Athene, c.*1531–8
Oil on canvas, 64 x 45.4 cm

The figure is identified by the cameo on her breastplate, which bears the inscription 'ATHENE'. Above is Victory, holding palm and olive branch, flying over a city, presumably Athens. Pallas Athene was a warrior, usually shown in armour, as well as being the Greek goddess of wisdom and patron of Athens. Parmigianino has stylised and distorted the figure of the goddess to create a mannerist ideal of beauty.

Left
28. GIULIO ROMANO
(c.1499–1546)
Portrait of Margherita
Paleologo, c.1531
Oil on panel, 115.5 x 90 cm

This portrait depicts
a noblewoman in a
magnificent black
overdress worn over a
pale crimson underdress.
The extraordinary pattern
of the overdress was known
as the 'knot-fantasies'
(*fantasie dei vinci*).
On her head she wears
an elaborate headdress
(*zazara*). In the room
behind her, a maidservant
greets two fashionable
ladies and a nun. The
portrait depicts Isabella
d'Este's daughter-in-law,
Margherita Paleologo
(1510–1566), at around
the time of her marriage
to Federico Gonzaga, 1st
Duke of Mantua, in 1531.

Above
29. WORKSHOP OF GIULIO
ROMANO (c.1499–1546)
Nero Playing while Rome
Burns, c.1536–9
Oil on panel,
121.5 x 106.7 cm

Commissioned by Federico
Gonzaga, Duke of Mantua,
Giulio Romano's scenes
from the lives of the Roman
emperors and emperors
on horseback (pls 29–31)
provided a decorative
setting for Titian's famous
11 portraits of *Emperors*

(now lost) in the Cabinet of
the Caesars, a room in the
Palazzo Ducale. This scene
would have hung beneath
Titian's painting of Nero.
The scene was taken from
Suetonius's *Twelve Caesars*
in which Nero sang as
Rome burned.

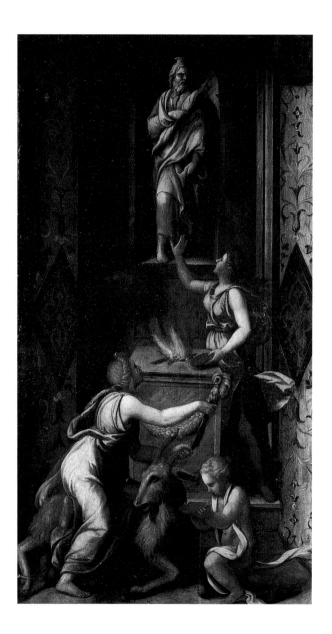

**30. Workshop of
Giulio Romano
(c.1499–1546)**
*The Sacrifice of a Goat
to Jupiter, c.1536–9*
Oil on panel,
123.0 x 66.2 cm

According to Suetonius,
the Emperor Domitian was
haunted by predictions of
death. He was prevented
from at least one act of
cruelty by a poem, which
prophesied that he would
be sacrificed like a goat if he
carried it out. Here beneath
a statue of Jupiter a goat is
prepared for sacrifice. The
tightness of space available
meant the format of this
panel is narrow.

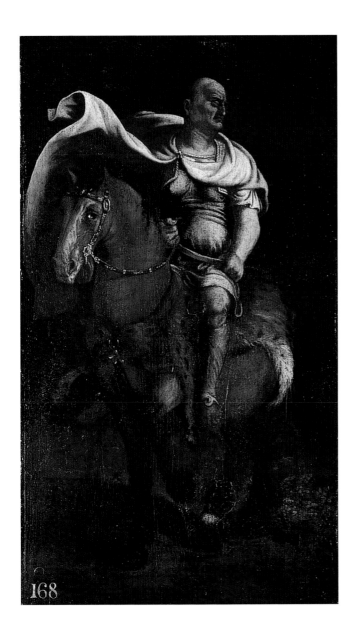

168

31. WORKSHOP OF GIULIO ROMANO (c.1499–1546)
An Emperor on Horseback,
c.1536–9
Oil on panel, 87 x 50.5 cm

In the Cabinet of the Caesars, panels showing the emperors on horseback framed the scenes from the lives of the emperors. This painting was on the west wall of the room and the portrait resembles the almost bald middle-aged head of Vespasian as recorded in copies of Titian's painting. Giulio designed the paintings but almost all were executed by his workshop.

32. PARMIGIANINO (1503–1540)
The Coronation of the Virgin,
*c.*1535
Pen and ink, brown and
grey wash, white heightening,
on grey paper, 18.7 x 17.5 cm

The commission to decorate
the church of Santa Maria
della Steccata in Parma
overshadowed the last decade
of Parmigianino's short and
mercurial life. The fresco in
the apse was to depict the

Coronation of the Virgin. In this
sketch the Madonna is borne
up by angels towards Christ,
seated on a rainbow and holding
out the crown towards her.
Parmigianino never began
work on the painting.

**33. PELLEGRINO TIBALDI
(1527–1596)**
*The Annunciation of the
Conception of the Baptist,*
c.1552–5
Pen and ink with wash
and white heightening over
red chalk, on buff paper,
42.3 x 28.4 cm, arched

In the early 1550s Tibaldi
designed and decorated
the Poggi chapel in San
Giacomo Maggiore,
Bologna. This is a study
for the fresco on the right
wall. The Gospel of St
Luke relates that the angel
Gabriel appeared to the
priest Zacharias, telling
him that his elderly wife
Elizabeth would bear him
a son. Here however the
angel swoops down into
the temple to announce the
news to Elizabeth herself.

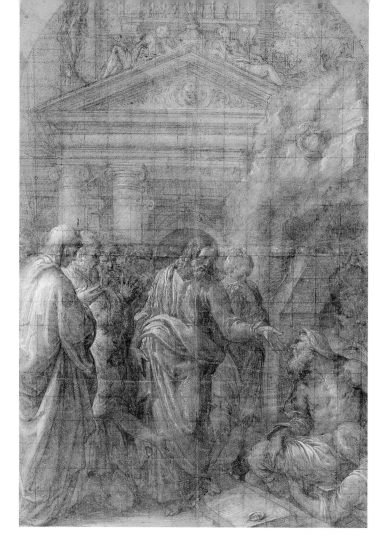

Right
35. FEDERICO BAROCCI
(1528/35–1612)
*The Calling of
St Andrew,* c.1580 (detail)
Pen and ink with wash,
white heightening
and some scratching out, over
black chalk and stylus, with
traces of squaring in black
chalk, on toned and
discoloured paper,
47 x 34.7 cm

This is Barocci's model for
his altarpiece of the *Calling
of St Andrew,* painted for the
oratory of the fishermen's
guild in Pesaro. The
painting was looted by
Napoleon's troops and is
now in Brussels. St Andrew
kneels before Christ, while
St Peter clambers out of
the boat in the background.
The drawing seems to have
been framed and displayed
unglazed for many years
before it reached the Royal
Collection, and is thus in
poor condition.

Above
34. GIULIO CAMPI
(C.1508–1573)
The Raising of Lazarus,
c.1547
Black chalk with white
heightening, squared in
black chalk, 81.5 x 52.5 cm

Giulio Campi designed and
decorated the whole of the
small church of Santa
Margherita in Cremona,
for its titular prior, the
humanist scholar Marco
Girolamo Vida. This is a
final study for the *Raising of*

Lazarus, one of six arched
frescoes in the side walls of
the barrel-vaulted church.
The scene is set against an
imposing architectural
backdrop reminiscent of
Campi's own architectural
works.

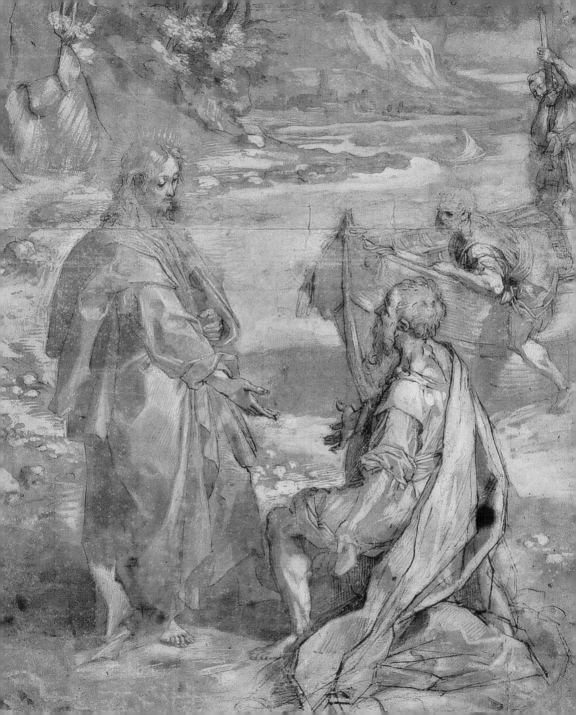

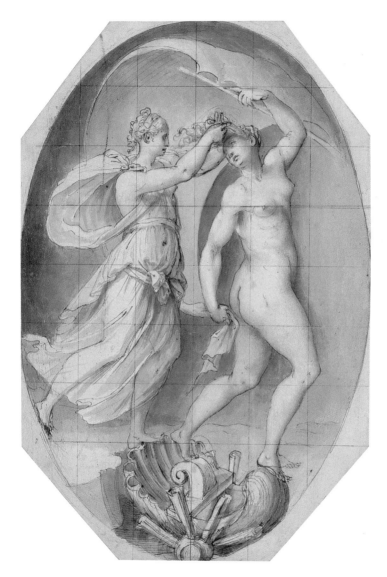

Left
36. PROSPERO FONTANA (c.1510–1597)
Virtue Subduing Fortune, 1553
Pen and ink with wash over black chalk, 36 x 24 cm, the corners cut

Prospero Fontana worked on several projects for Pope Julius III between 1550 and 1555, including the decoration of the Pope's private residence, the Villa Giulia in Rome. This is a study for an oval relief in stucco, at the centre of a ceiling in the villa. The motif of Virtue subduing Fortune was Julius's personal device.

Right
37. CAMILLO PROCACCINI (c.1555–1629)
An Old Man and a Youth, c.1585
Red chalk, 37.8 x 31.7 cm

The drawing corresponds with two figures in Procaccini's first major fresco, the *Last Judgement* in San Prospero, Reggio Emilia. It is unusually close in detail to the fresco, including the background elements. Perhaps the patrons were not confident about the young artist's ability to see through a project of this scale, and required him to produce unusually explicit preparatory drawings.

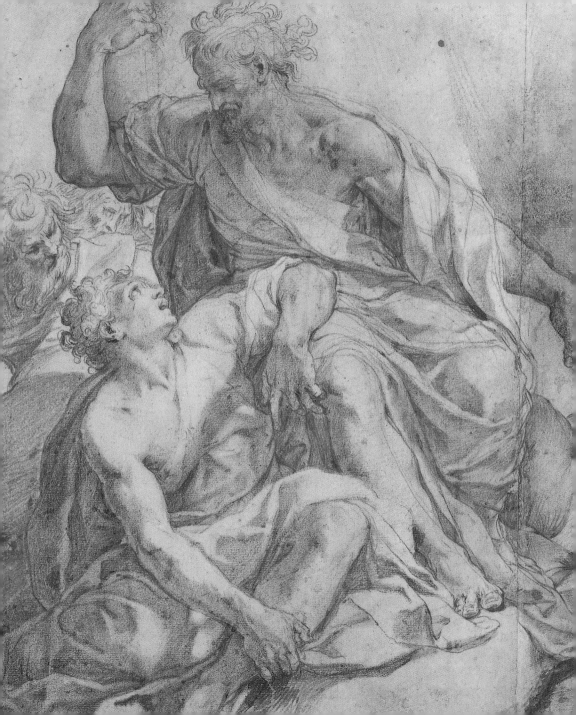

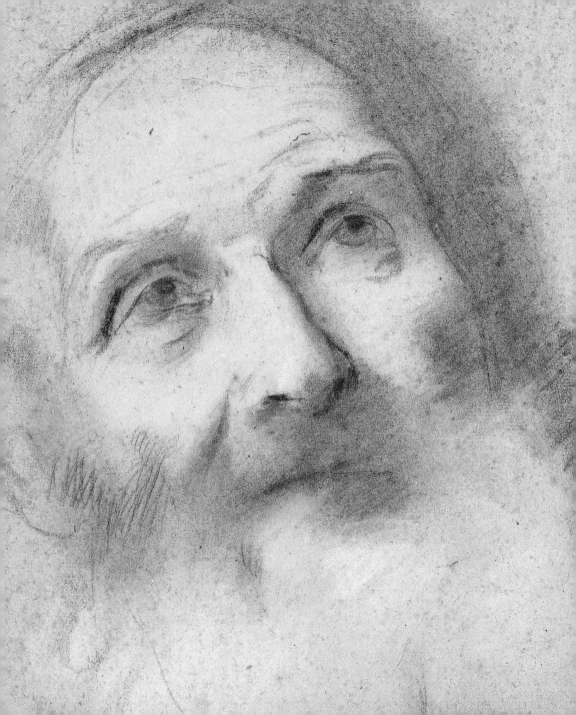

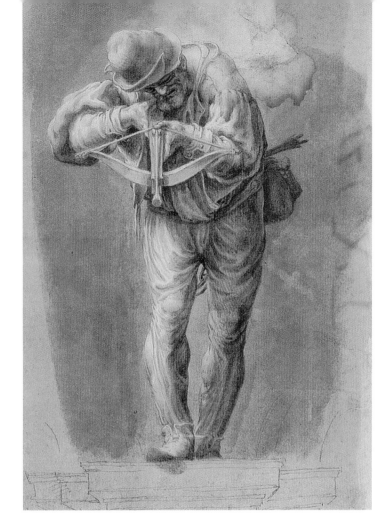

Left
38. Federico Barocci
(1528/35–1612)
The Head of an
*Old Man, c.*1575 (detail)
Black, white and coloured
chalks on pale blue-green
paper, 34.6 x 25.4 cm

A chronic illness restricted
Barocci's painting activity
to short periods in the
morning and evening.
But he was a prolific
draughtsman, and used
coloured chalks more
extensively than any other
artist before the eighteenth
century, allowing him to
determine both lighting
and colour in a preparatory
sheet. This may be a study
for one of the background
heads in his altarpiece
known as the *Madonna
del Popolo* (Uffizi).

Above
39. Lelio Orsi
(1508/11– 1587)
*A Crossbowman, c.*1575
Pen and ink, brush and
yellow-brown ink, white
heightening, over black
chalk, 25.2 x 19.8 cm

Orsi frescoed the façades
of many houses, but
only fragments of these
decorations survive.
This seems to have been a
study for the façade of his
brother's house in Reggio
Emilia. A crossbowman
aims his bolt at passers-by
in the street below; other
preparatory drawings for
the scheme show that Orsi
filled the modest surface
area with fire and cloud,
collapsing columns and
struggling nudes, no doubt
as an advertisement of his
talents.

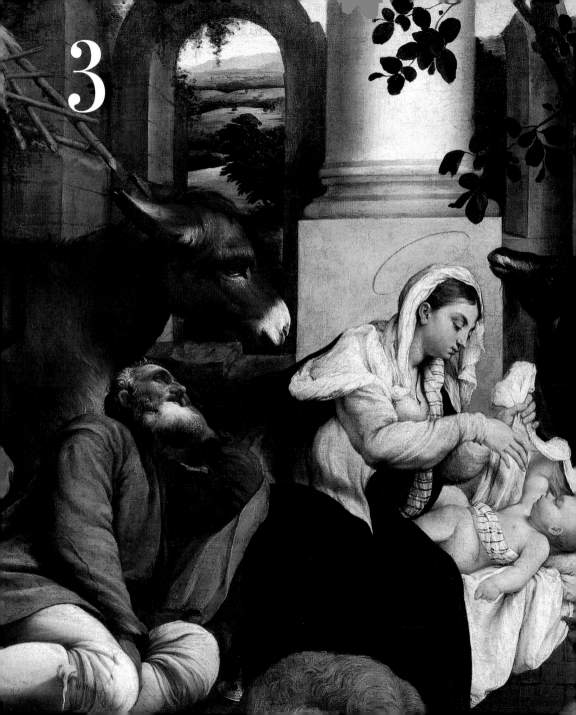

Previous pages
**40. JACOPO BASSANO
(C.1510–1592)**
*The Adoration of the
Shepherds, c.*1546 (detail)
Oil on canvas,
139.1 x 218.5 cm

The birth of Christ takes
place in a ruined temple,
symbolising Judaism being
superseded by Christianity.
The unusually prominent
goat may represent a
prefiguration of Christ
as the 'scapegoat' who
carries the sins of the world.
Bassano borrowed many

elements here from works
by Titian, Dürer and
Pordenone. However the
direct naturalism of the
animals, his native town
in the background, and the
striking realism of the
shepherd, far right, are
particular to Bassano.

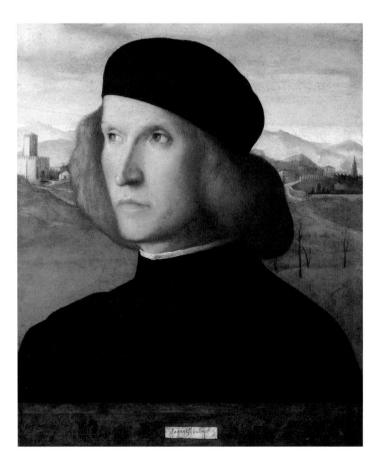

**41. GIOVANNI BELLINI
(C.1431/36–1516)**
*Portrait of a Young
Man, c.*1505
Oil on panel, 43.8 x 35.2 cm

This is Bellini's last
surviving portrait and
the only one to include
a landscape background.
The portrait follows a
characteristic Bellini format
of head and shoulders seen
in three-quarter view behind
a parapet. It is signed on
a *cartellino* or fictive label,
apparently attached to the
parapet. The subject wears
the black *biretta* and robe
of a Venetian *cittadino*,
the social group below the
patrician class. It has been
suggested that he may be
the Venetian writer and
humanist Pietro Bembo
(1470–1547).

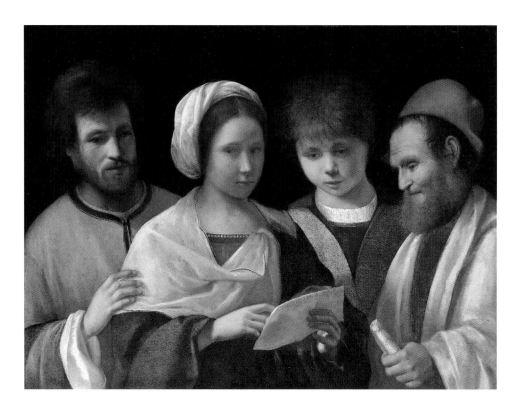

Above
**42. ATTRIBUTED TO
VITTORE BELLINIANO
(fl. 1507–1529)**
The Concert, c.1505–15
Oil on canvas,
77.7 x 99.6 cm

The figures in this haunting painting are probably singing from a score held by the woman, who seems to be beating time with her finger. The figures may also represent the three ages of man (childhood, adulthood, old age) adding a philosophical dimension to the idea of 'measuring time'. The painting has previously been attributed to Giorgione, but it is more likely to be by this pupil of Giovanni Bellini.

Right
**43. ATTRIBUTED TO TITIAN
(c.1485/90–1576)**
Boy with a Pipe
(*'The Shepherd'*), 1510–15
(detail)
Oil on canvas,
62.5 x 49.1 cm

Titian was apprenticed to Gentile and then Giovanni Bellini, before working with Giorgione, whose death in 1510 left him without a rival in Venice. The boy here seems to be lost in thought, glancing down as if he has just stopped playing the pipe. Titian may have based this work on a lost original by Giorgione. In his creation of this type – the poetic single figure – Giorgione was probably inspired by Leonardo da Vinci.

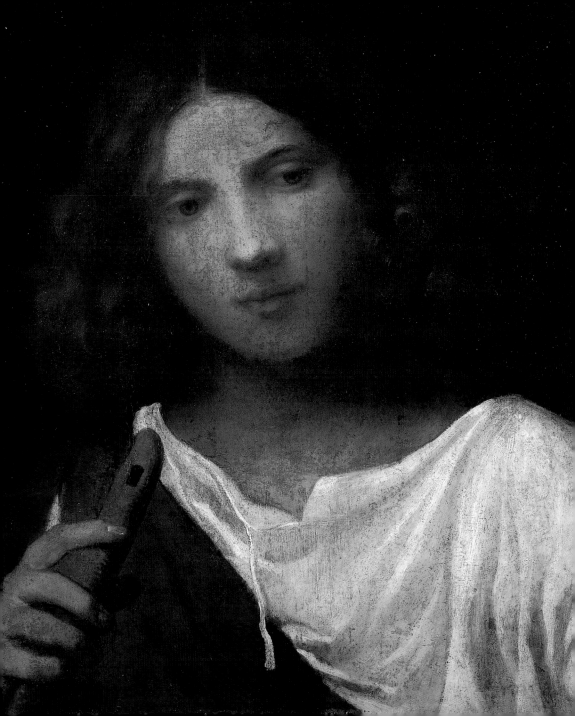

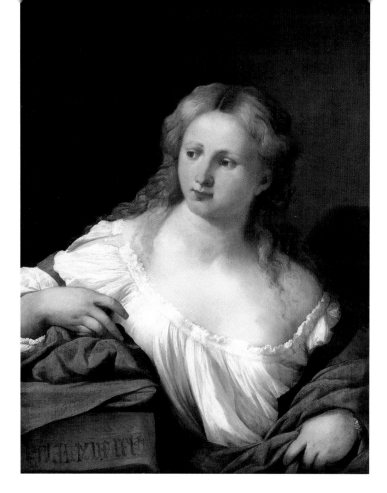

**45. TITIAN
(c.1485/90–1576)**
*Portrait of Jacopo
Sannazaro(?), c.1512–15*
(detail)
Oil on canvas,
85.7 x 72.7 cm

Titian's portraiture was
especially admired; he
recorded the features
of friends, writers and
Venetian noblemen before
his international fame
led to commissions from
European rulers. This
nobleman seems lost in
thought, his finger tucked
in a book to keep his place.
It has been suggested that
he is the Neapolitan poet
and humanist Jacopo
Sannazaro (1458–1530).
However, this man's
features differ from other
likenesses of Sannazaro
and this may be the portrait
of another humanist yet to
be identified.

Above
**44. PALMA VECCHIO
(c.1480–1528)**
A Sibyl, c.1522–24
Oil on panel,
74.3 x 55.1 cm

Inspired by Titian's *Flora*
(Uffizi), the seductive but
idealised female half-length
was one of Palma Vecchio's
specialities, which he
established as a theme for
Venetian art of the period.
The title here is based on
the idea that the 'arabic'
inscription at bottom left
alludes to sibylline mysteries,
whereas in fact they are a
meaningless combination
of letters. The woman's
idealised appearance may
have been inspired by the
look of Venetian courtesans
at the time and also reflects
descriptions of erotic beauty
in literature.

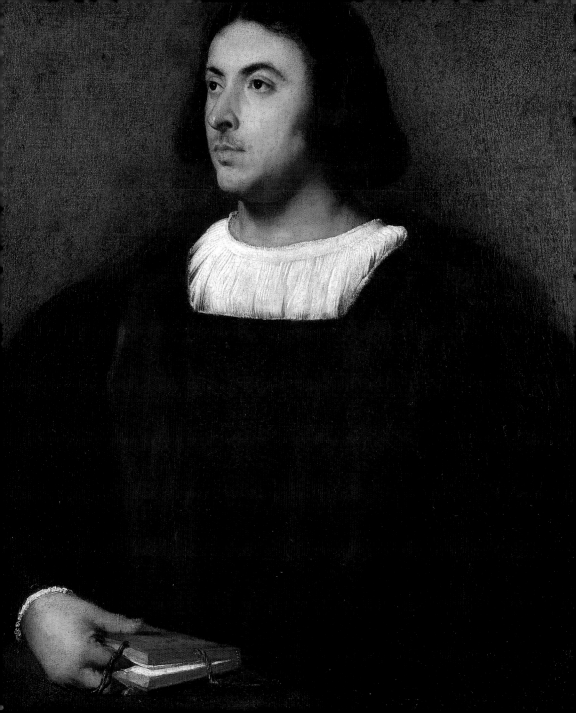

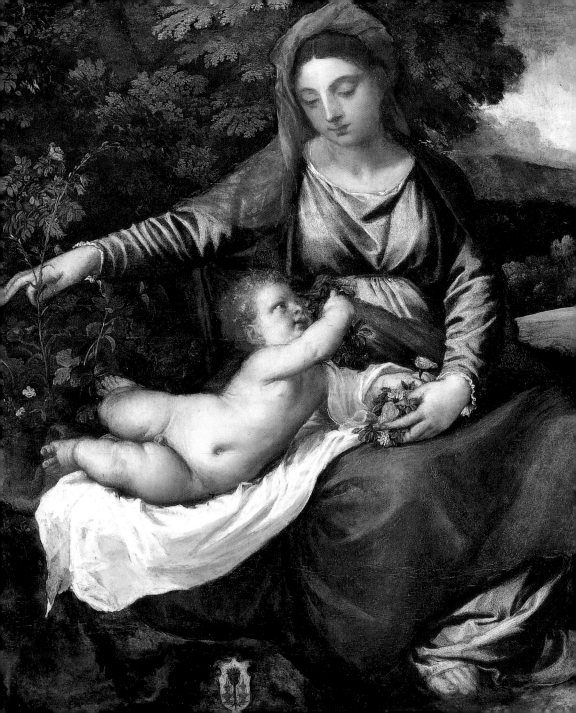

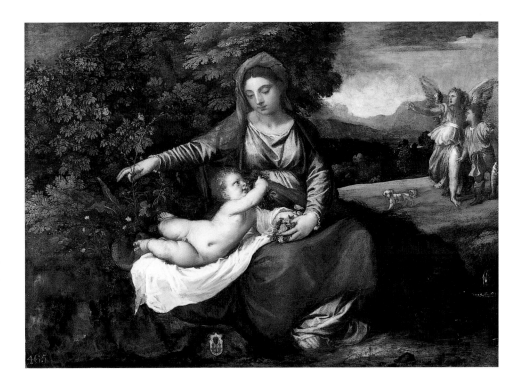

46. TITIAN
(c.1485/90–1576)
AND WORKSHOP
The Virgin and Child in a
Landscape with Tobias and
*the Angel, c.*1535–40
Oil on panel,
85.7 x 120.2 cm

This is one of four closely
related compositions by
Titian and his workshop
representing the Virgin and
Child in a landscape. Here
they sit on a sandy bank
by a stream set within the
artist's own mountain
landscape of the Dolomites.
The Virgin turns towards a

spread of roses, but picks
a single campanula, while
Christ selects a red rose
from the flowers gathered
in their hands. The flowers
and 'enclosed garden' are
symbols of Mary's virginity;
the red rose also alludes to
Christ's Passion.

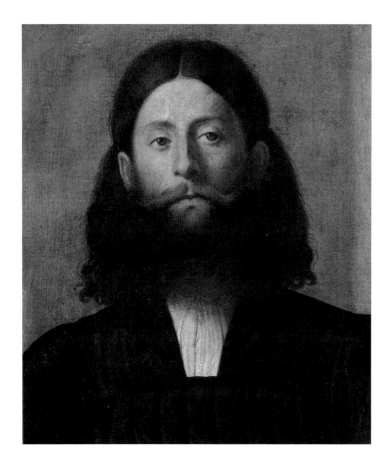

Right
**48. GIROLAMO ROMANINO
(C.1484/7–C.1560)**
Portrait of a Man, c.1515–17
(detail)
Oil on panel, 82.1 x 68.9 cm

Romanino's style was
strongly influenced by the
Venetians Giorgione and
Titian, and by Lombard and
German artists, especially
Dürer. In this early work
the sitter wears a wide-
brimmed hat over a gold-
decorated cap, worn by
soldiers in the early
sixteenth century to keep
their shoulder-length hair
out of the way. However,
soldiers were usually
depicted with more armour
and weapons, so the sitter
here is probably a north
Italian nobleman rather
than a professional soldier.

Above
**47. LORENZO LOTTO
(C.1480–1556/7)**
*Portrait of a Bearded Man,
c.1515–18* (detail)
Oil on canvas, 53.6 x 40 cm

Lotto was one of the most
inventive and idiosyncratic
painters of the sixteenth
century and a serious rival
of Titian, Palma Vecchio
and Pordenone. The almost
full-frontal pose he uses
here gives this searching
and sensitive portrait a
focused intensity that

recalls Dürer's work, but
with a Venetian softening of
contours. The portrait has
the clarity typical of Lotto's
style, for example the way
in which the sitter's paler
moustache contrasts with
his darker hair and the
tactile effect of the pleats
of his doublet.

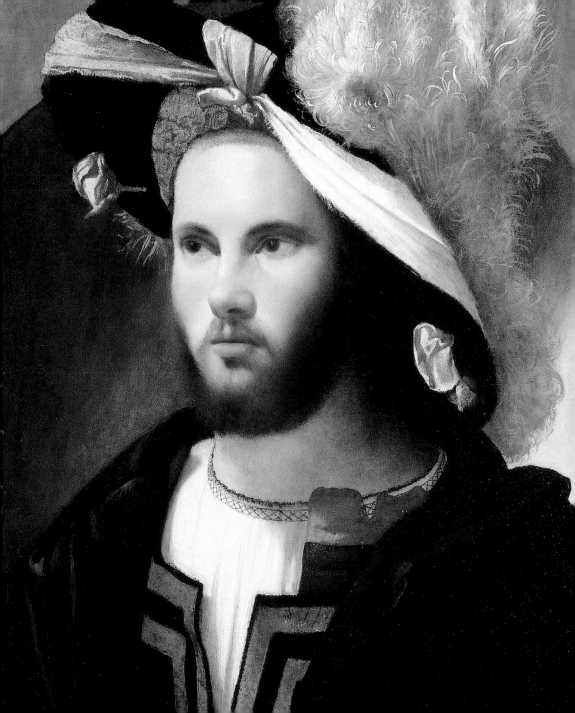

**49. LORENZO LOTTO
(c.1480–c.1556)**
*Portrait of Andrea
Odoni,* 1527
Oil on canvas,
104.6 x 116.6 cm

This is one of the most
innovative and dynamic
portraits of the Italian
Renaissance. The suc-
cessful Venetian merchant
Andrea Odoni (1488–1545)
was a renowned collector
of paintings, sculpture,
antique vases, coins,
gems and natural history
objects. In his right hand he

holds a statuette of
Diana or Artemis of the
Ephesians, perhaps a
symbol of nature or earth;
with his left he clutches a
golden cross to his chest.
One possible meaning is
that for Odoni Christianity
will always take precedence
over nature and the pagan
gods of antiquity.

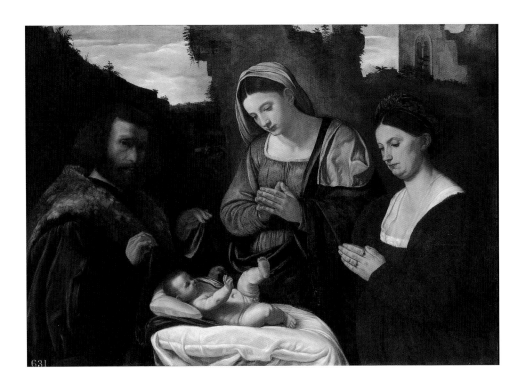

**50. GIROLAMO SAVOLDO
(c.1480–1548)**
*The Virgin Adoring the Child
with Two Donors, c.*1527
Oil on canvas,
102.2 x 139.7 cm

This is a rare example of a signed and dated painting by Savoldo. The date is now indecipherable, although the concentrated colours and glossy metallic effect of the folds of drapery are typical of Savoldo's work in the late 1520s. The Virgin or a saint usually performs the donor's action of lifting the cloth to reveal the Christ Child; it may suggest a premonition of his later shroud. The distant vista and close observation of natural details reflect Savoldo's interest in Netherlandish and German art.

**51. Palma Vecchio
(c.1480–1528)**
*The Virgin and Child with
Sts Catherine of Alexandria
and John the Baptist,
c.1527–8 (detail)*
Oil on panel, 60 x 81.5 cm

This successful formula
of the Virgin and saints
in a landscape ('*sacra
conversazione*') was one
of Palma's specialities. He
was inspired by Titian to
devise dynamic, focused
compositions and to
integrate his heroic, richly
dressed figures into a
poetic, sunlit landscape.
Sacre conversazioni were
much in demand by the
Venetian middle class
for private devotion (or
decoration). Here Christ
looks anxiously back at
his mother, not wishing to
accept the lamb, symbol of
his destiny, from St John.

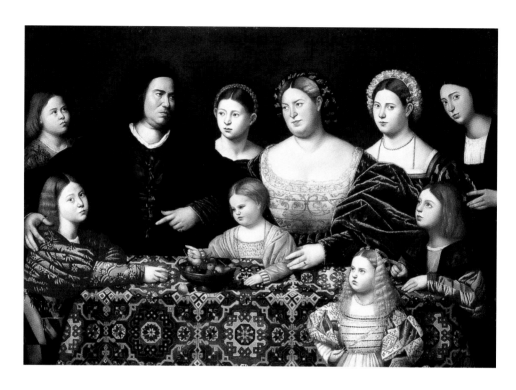

52. Bernardino Licinio
(c.1490–after 1549)
A Family Group, 1524
Oil on canvas,
123.2 x 177.3 cm

Licinio was born in Venice
to a Lombard family.
Although he trained in
the workshop of Giovanni
Bellini, Licinio seems to
have preserved the down-
to-earth realism typical
of Lombard painting.
This unidentified family
is grouped around a
magnificent Turkish

table carpet. The father
is attempting to resolve
a dispute between the
younger children. The boy
on the left has taken an
apple from the bowl, much
to the displeasure of his
siblings, particularly the
young girl nearest the
viewer.

**53. JACOPO BASSANO
(c.1510–1592)**
*The Journey of Jacob, c.*1561
Oil on canvas,
129.4 x 184.2 cm

This is an early example of
an Old Testament pastoral,
one of Jacopo's specialities.
Jacob had served his father-
in-law Laban for fourteen
years and won most of his
sheep and goats by a trick.
Here we see Jacob setting
off with his wives, children

and livestock to return to
his father, Isaac, in Canaan
(Genesis 21: 17–21). The
restrained use of strong
colours and the softness
of the light convey the
atmosphere of Jacob's
secret escape.

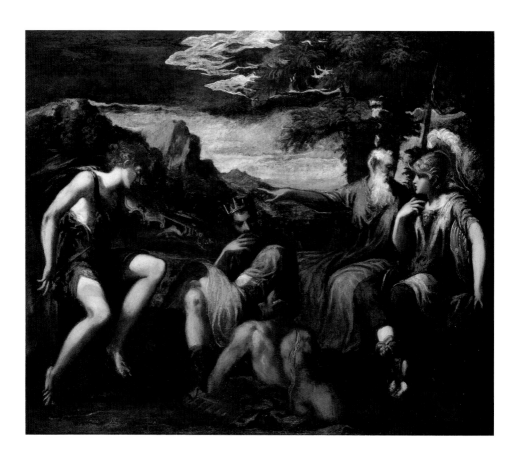

54. ANDREA SCHIAVONE
(C.1510–1563)
The Judgement of Midas,
*c.*1548–63
Oil on canvas,
167.6 x 197.7 cm

Schiavone's family came
from the Romagna but had
settled in Dalmatia, which
is why he was known as
'Schiavone' ('the Slav'). His
rapid and free brushwork
was said to have amazed
Titian and is used here to
heighten the dramatic mood
of the story. In this story
from Ovid's *Metamorphoses*,

Pan boasts that his reed
pipes make better music
than Apollo's lyre. Tmolus,
the local mountain god,
turns to Minerva (on the
extreme right) and chooses
Apollo as the victor. Midas,
King of Phrygia, disputes the
verdict. As punishment,
Apollo gives Midas ass's
ears, barely indicated here.

**55. Leandro Bassano
(1557–1622)**
Portrait of Tiziano Aspetti,
c.1592–3
Oil on canvas, 88 x 67.2 cm

This is almost certainly a
portrait of Tiziano Aspetti,
one of the leading sculptors
in Venice at the end of
the sixteenth century. In
1590 he and the sculptor
Girolamo Campagna were
commissioned to carve
colossal marble figures to
flank the entrance to the
Public Mint (*Zecca*) in
Venice. The statuette here
is probably Aspetti's wax
model for his colossal
statue of Hercules. This
portrait was presumably
painted to celebrate
the completion of this
prestigious public
commission.

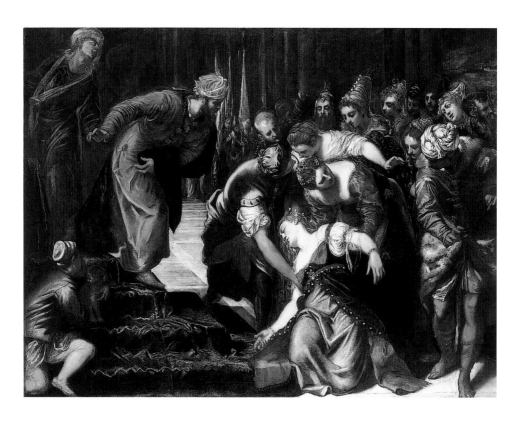

56. TINTORETTO
(1519–1594)
Esther before Ahasuerus,
*c.*1546–7
Oil on canvas,
207.7 x 275.5 cm

This story is told in the Old
Testament Book of Esther.
King Ahasuerus's second
wife, Esther, has concealed
her Jewish identity from
him. She learns that the
King's chief minister is
plotting to have all the
Jews in the Persian Empire
massacred. Esther

intercedes with the King
and he eventually grants
her request to spare her
people. Tintoretto shows
her fainting with fear
before Ahasuerus. The
intense colours create
an impression of exotic
splendour, while strong
light heightens the drama.

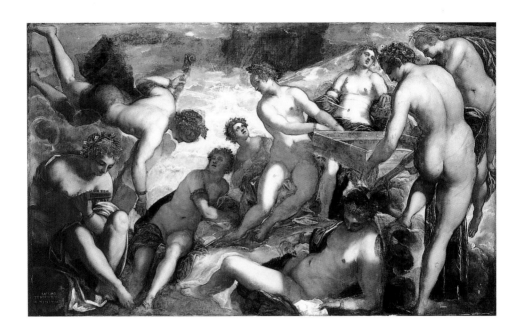

57. TINTORETTO
(1519–1594)
*The Muses, c.*1578
(photographed during
conservation)
Oil on canvas,
206.7 x 309.8 cm

This painting and pl. 56
used to hang together
in same passage of the
Palazzo Ducale, Mantua.
We know that Guglielmo
Gonzaga, the 3rd Duke of
Mantua, purchased other
paintings directly from
Tintoretto and visited him
in Venice. The nine Muses
were originally seen as the
divine inspiration for poetry,

song and dance, but
gradually became the
emblems for all the liberal
arts. With Apollo (here
represented as the sun)
they also symbolised the
'harmony of the spheres'.
Here Tintoretto's sweeping
strokes have created
powerfully articulated
nudes who fly and turn
with extraordinary freedom.

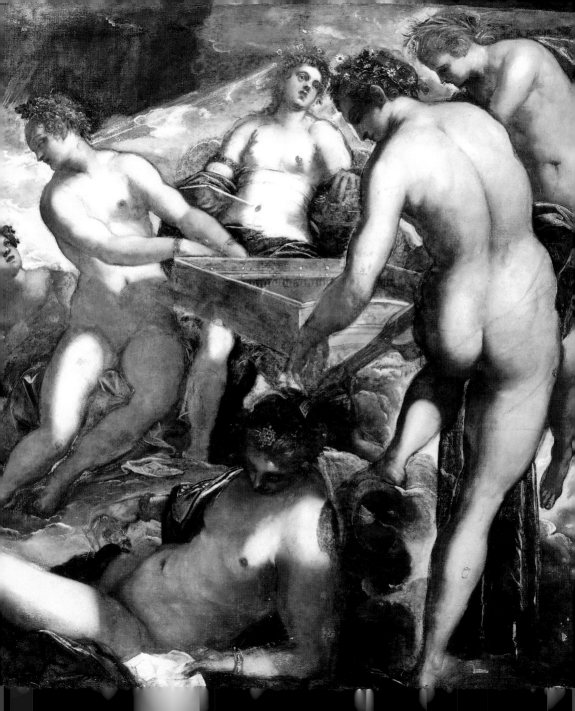

**58. Lodovico
Pozzoserrato
(c.1550–c.1605)**
*A Pleasure Garden with
a Maze, c.*1579–84
Oil on canvas,
147.4 x 200 cm

The northern artist
Lodewijk Toeput italianised
his name to Pozzoserrato;
his work is also an
interesting combination
of Netherlandish and
Venetian styles. This fas-
cinating pleasure garden
reflects a variety of visual
and literary sources, as well

as real gardens of the
period. At its heart lies
a clipped-hedge maze
or labyrinth filled with
amorous couples, some
enjoying a banquet in
the centre. A view of the
Piazzetta di San Marco in
Venice can be seen in the
distance, top right.

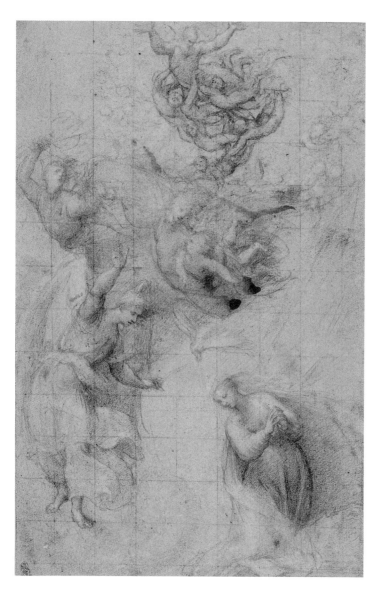

59. PORDENONE
(1483/84–1539)
*The Annunciation, c.*1537
Black and white chalks on
blue paper, squared in black
chalk, accidental ink stains,
38.9 x 25 cm

Pordenone's large altar-
piece of the *Annunciation*,
still in the church of Santa
Maria degli Angeli on the
Venetian island of Murano,
was his last major work.
The dedication of the
church explains the
presence – in addition to
the annunciatory Gabriel –
of the archangel Michael
at centre left, with his
scales for weighing human
souls, and the guardian
angel Raphael at upper
centre, his arm around
the child Tobias.

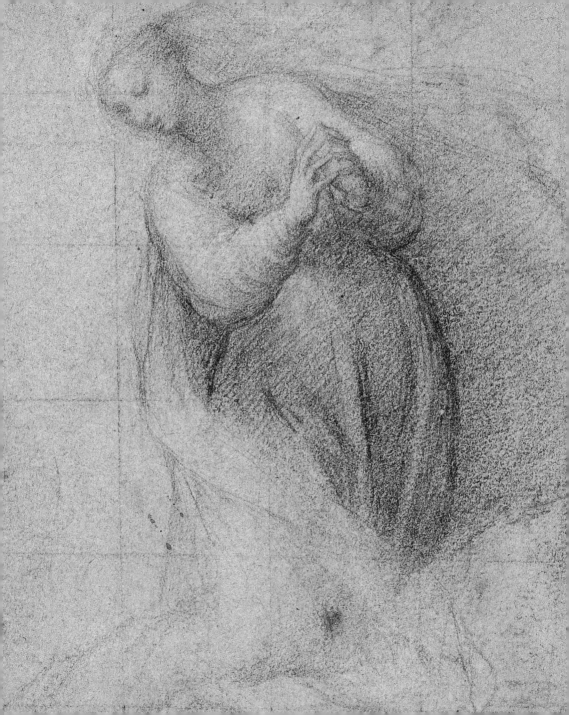

**60. TINTORETTO
(1518–1594)**
*A Man from Behind, c.*1555
Black and white chalks, with
white heightening and
brown oil paint, on blue
paper, 36.8 x 18.8 cm

The drawing is a study for a
man at the foot of a ladder
in Tintoretto's *Crucifixion*,
painted for the church of
San Severo, Venice and
now in the Accademia. It is
a finely preserved example
of the artist's rapid drawing
technique, with the line
of the cross in the final
composition added with a
couple of strokes of brown
oil paint. Such drawings
must have been executed
in huge numbers by
Tintoretto, but only a tiny
proportion survive.

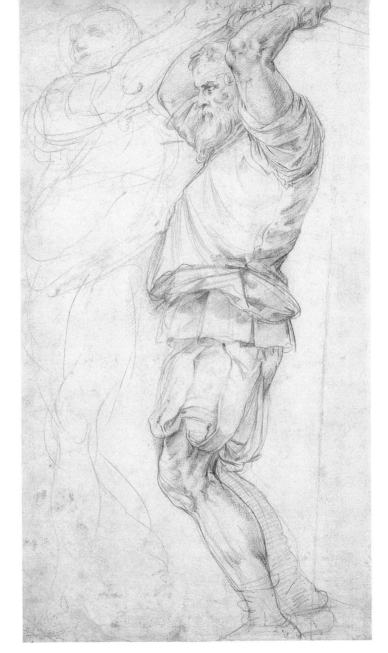

61. Battista Franco
(1510?–1561)
*A Flagellator, c.*1555
Red chalk,
40.4 x 22.4 cm

Franco spent much of
his career in Rome and
Florence, and on his return
to his native Venice he
continued to work in a
central Italian style, seen
here in the precision of the
chalk lines. His eclectic
and sometimes chaotic
paintings were less
successful than his prints,
of which he produced about
a hundred, sometimes on
an unusually large scale.
This is a study for his
engraving of the
Flagellation of Christ.

Left

62. ATTRIBUTED TO GIROLAMO SAVOLDO (c.1480–1548)
The Head of a Man,
c.1520–30 (detail)
Black and white chalks
on blue paper,
37.6 x 26.0 cm

No completely convincing
attribution has been
proposed for this
impressive (though sadly
damaged) head study. The
old inscription shows that
an early collector judged it
to be Florentine, but blue
paper is more commonly
found in northern Italy.
Recently it has been
claimed as the work of
Savoldo, most of whose few
known drawings are of this
type, black chalk heads on
blue paper.

**63. PAOLO FARINATI
(1524–1606)**
The Emperor Vespasian,
c.1560–80
Black chalk, pen and ink,
brush and ink, and white
heightening on paper
washed pale brown,
39.4 x 27 cm

Paolo Farinati produced
many decorative cycles for
the private residences of
Verona, though only a
small proportion survive.
This is one of a set of 11
known drawings by the
artist depicting rulers of
ancient history, including

Julius Caesar, Alexander
the Great, King Sapor of
Persia, and Attila the Hun.
They may have been
intended to be painted
as the decoration of a
library, traditionally
furnished with portraits
of great men.

THE SEVENTEENTH CENTURY

Previous pages
**64. ORAZIO GENTILESCHI
(1563–1639)**
Joseph and Potiphar's Wife,
*c.*1630–32 (detail)
Oil on canvas,
206 x 261.9 cm

Joseph was bought by
Potiphar, the captain of
Pharoah's guard, and
appointed overseer of his
household (Genesis 39:
7–20). Potiphar's wife
attempted to seduce
Joseph, but he rejected her.
One day she caught him
by his garment and said
'lie with me'; Joseph fled
leaving the garment in her
hands. Later Potiphar's
wife used it as evidence
that Joseph had seduced
her. The painting (see also
fig. 6) was one of a group
by Gentileschi brought
together by Henrietta Maria
to decorate the Queen's
House, Greenwich.

Above
**65. ANNIBALE CARRACCI
(1560–1609)**
Head of a Man in Profile,
*c.*1588–95 (detail)
Oil on canvas,
44.8 x 32.1 cm

This vivid head is exactly
the type of study from
everyday life practised
so passionately by the
Carracci during their early
years in Bologna. These
studies from nature,
painted with such
sympathy and with broad
open brushwork, were in
deliberate contrast to the
dry, 'statuesque' style of
the previous generation
of Mannerist painters.
The directness and
looseness of handling
in this small informal
portrait suggest Annibale's
extraordinary confidence
and spontaneity of touch.

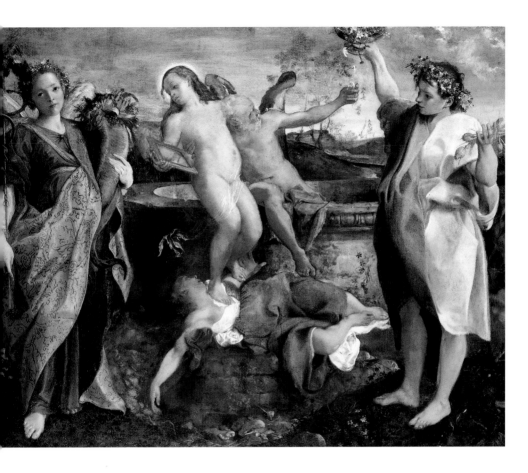

**66. ANNIBALE CARRACCI
(1560–1609)**
*An Allegory of Truth
and Time, c.*1584–5
Oil on canvas,
130 x 169.6 cm

In the centre, the winged
figure of Time (holding an
hourglass) has brought his
daughter, Truth, from the
depths of a well to reveal
her to the light of day. Truth
radiates light and looks in
a mirror, which presents a
true image of the world.

Two-faced Deceit is
trampled under Truth's feet.
Framing the scene on the
right is Happy Ending and
on the left, Happiness or
alternatively Good Luck.
The moral seems to be both
'All's well that ends well'
and 'the truth will out'.

**67. ANNIBALE CARRACCI
(1560–1609)**
*The Madonna and Sleeping
Child with Infant St John
the Baptist ('Il Silenzio'),*
c.1599–1600
Oil on canvas,
51.2 x 68.4 cm

In this small devotional
painting, the Virgin raises
her finger to her lips to
warn John the Baptist not
to wake the sleeping Christ.
Christ's future sacrifice
is alluded to by the
resemblance of the table
to an altar or tomb and the

shroud-like cloth on which
he sleeps. The cherries,
of which one has already
been eaten, symbolise
heaven. The Virgin's
gesture may be read as
cautioning John not to
awaken Christ to his
Passion before his time.

Below
68. CARAVAGGIO
(1571–1610)
The Calling of Saints Peter and Andrew, c.1602–4
Oil on canvas, 140 x 176 cm

The young Christ gestures ahead while turning back to the brothers Simon (later called Peter) and Andrew, who have been fishing by the Sea of Galilee. He says 'Follow me and I will make you become fishers of men' (Mark 1:16–18). Peter, holding two fish, starts back in surprise; Andrew points to himself incredulously. The fishermen's weather-beaten hands express with great eloquence their astonishment, confusion and fear. Christ's gesture and movement forwards suggest his confidence that the brothers will follow him.

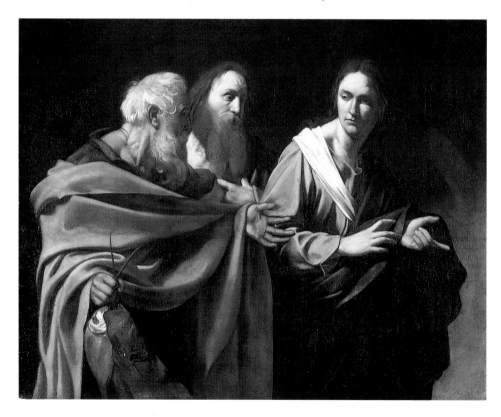

Opposite
69. CARAVAGGIO
(1571–1610)
Boy Peeling Fruit, c.1592–3
Oil on canvas, 63 x 53 cm

Caravaggio was probably the most influential painter of the early seventeenth century. This may be his earliest surviving painting, from his first years in Rome. There are several versions of this composition, all showing a boy peeling a citrus fruit, probably a green Seville or Bergamot orange. Here we see Caravaggio's typically Lombard interest in recording reality, with posed model and still life, which was to continue throughout his career.

Right
71. DOMENICO FETTI
(1588–1623)
*David with the Head
of Goliath, c.*1620 (detail)
Oil on canvas,
153 x 125.1 cm

Fetti painted this work and
pl. 79 at the height of his
career while employed at
the court in Mantua. This
painting depicts the Old
Testament story of the
shepherd boy David who
triumphed over the giant
Goliath (1 Samuel 17:
41–51). Using a single
stone from his sling,
David killed Goliath and
then decapitated him with
Goliath's huge sword. In
the background the giant's
corpse lies on the battlefield
as the Israelites triumph
over the Philistines.

Above
70. CRISTOFANO ALLORI
(1577–1621)
*Judith with the Head
of Holofernes,* 1613
Oil on canvas,
120.4 x 100.3 cm

According to the apocryphal
Book of Judith, the Israelite
widow Judith apparently
betrayed her people by
entering the camp of
the Assyrian general
Holofernes. He attempted
to seduce her, but was
overcome by drink. Judith
decapitated him with his
own sword and brought his
head back to her people.

Here the severed head is
claimed to be a self-portrait
of the artist; Judith and her
servant are said to resemble
Allori's mistress Maria di
Giovanni Mazzafirri and
her mother. According
to his biographer, Filippo
Baldinucci, Allori painted
this work in part as a
response to being deserted
by '*La Mazzafirra*'.

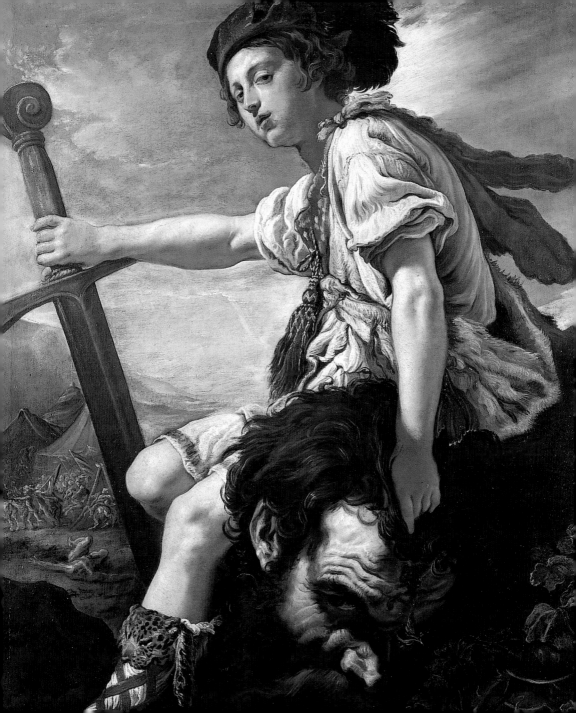

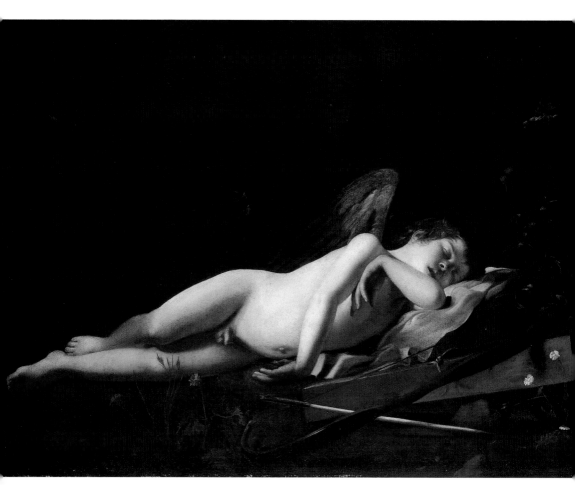

72. GIOVANNI BATTISTA CARACCIOLO (1578–1635)
*Cupid Sleeping, c.*1618
Oil on canvas,
92.3 x 127.1 cm

The subject of the sleeping Cupid owed much of its popularity to a sculpture by Michelangelo – a copy of a Hellenistic marble which he passed off as a genuine antiquity. Caravaggio and his circle were particularly interested in this forgery. Here the winged boy-god of love sleeps; his bow and arrows lie idle while flowers grow around him. The message is that we are only safe from Cupid's mischief when he sleeps. Caracciolo's inspiration here would seem to be Caravaggio's own version of the subject (Pitti Palace, Florence).

73. Anastasio Fontebuoni (1571–1626)
Madonna di Pistoia,
1621–23
Oil on canvas,
172.3 x 132.4 cm

Ferdinando Gonzaga, 6th Duke of Mantua, commissioned this painting from the Florentine Fontebuoni in about 1621. It depicts the miraculous vision of the Madonna of Pistoia who appeared to a local girl in 1336. While the girl was ill in hospital, the Virgin Mary came to her in a dream, holding the Christ Child in her arms. Fontebuoni based his composition on a fourteenth-century fresco of the vision in the Church of the Madonna delle Grazie o del Letto, Pistoia, not far from Florence.

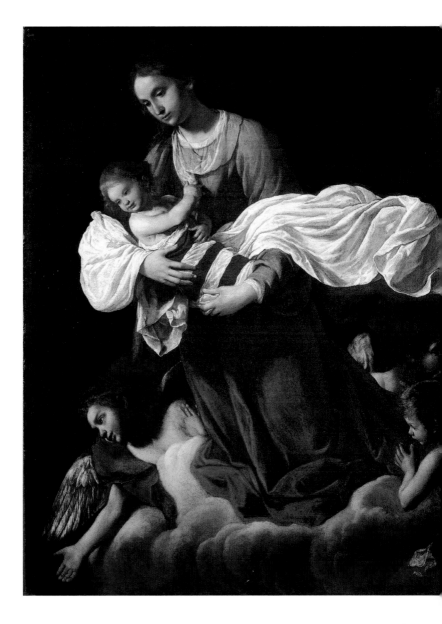

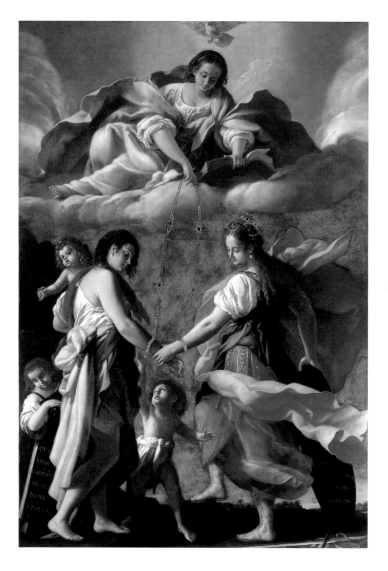

**74. GIOVANNI BAGLIONE
(c.1566–1643)**
*An Allegory of Charity and
Justice Reconciled,* 1622
Oil on canvas,
255.3 x 227 cm

This work was probably
painted for Ferdinando
Gonzaga, 6th Duke
of Mantua, who in 1617
commissioned a picture
of 'Justice and Peace
embracing each other'.
It expresses the idea that
Justice must be tempered
by Charity, the source and
origin of Mercy. Here
Justice and Charity are
bound together by a
golden chain held by
Divine Wisdom. The
painting would have
enhanced Ferdinando
Gonzaga's image as
a magnanimous and
just ruler.

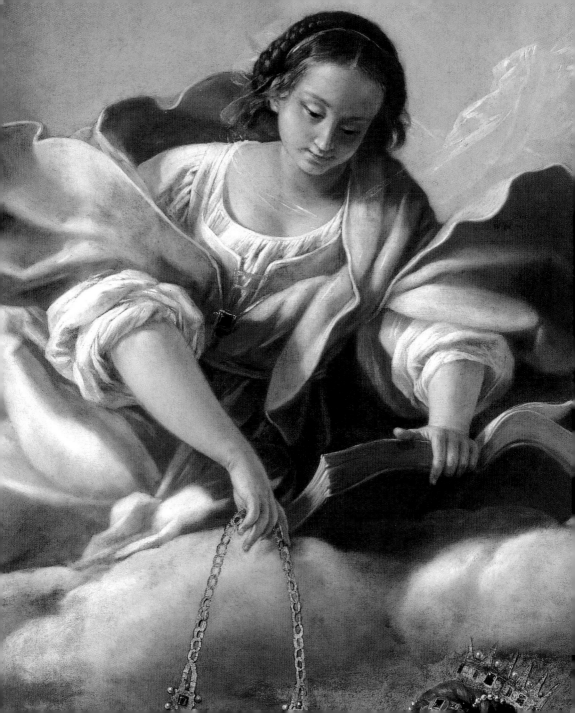

75. ALESSANDRO TURCHI
(1578–1649)
Four Organ Shutters, 1606

In 1606, the Accademia
Filarmonica in Verona
commissioned Turchi to
paint the shutters of an
organ, the centrepiece
of its newly built music
hall. The Accademia had
been founded in 1543 to
encourage the creation and
study of music, and three
years after the commission,
Alessandro Turchi was
appointed its official painter.
The figures for the shutters
were grouped in pairs: when
closed, one continuous
niche was formed with
Honour(?) on the left and
Virtue(?) on the right; when
open, *Music* was on the left
with *Poetry* on the right.

Honour(?)
Oil on canvas,
131.4 x 60 cm

Virtue(?)
Oil on canvas,
131.5 x 60.2 cm

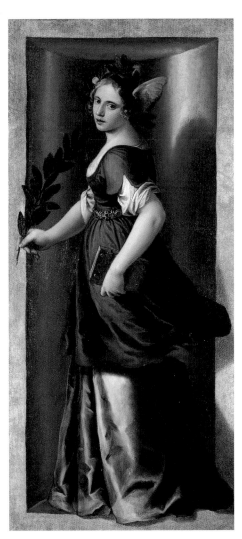

Music
Oil on canvas,
131.2 x 60.4 cm

Poetry
Oil on canvas,
131.2 x 59.8 cm

76. DOMENICHINO
(1581–1641)
*St Agnes, c.*1620
Oil on canvas,
212.7 x 152.4 cm

In 1605 the remains of
the fourth-century martyr
St Agnes were discovered
in Rome. Agnes, con-
demned to death by the
Emperor for her Christian
faith, miraculously survived
attempts to kill her until
she was finally beheaded.
Domenichino shows the

saint gazing heavenwards
while an angel holds a
crown and martyr's palm
above her. The large
classical vase and relief
sculpture signify the pagan
beliefs she has rejected;
the lamb (*agnus* in Latin)
refers to her purity and
her name.

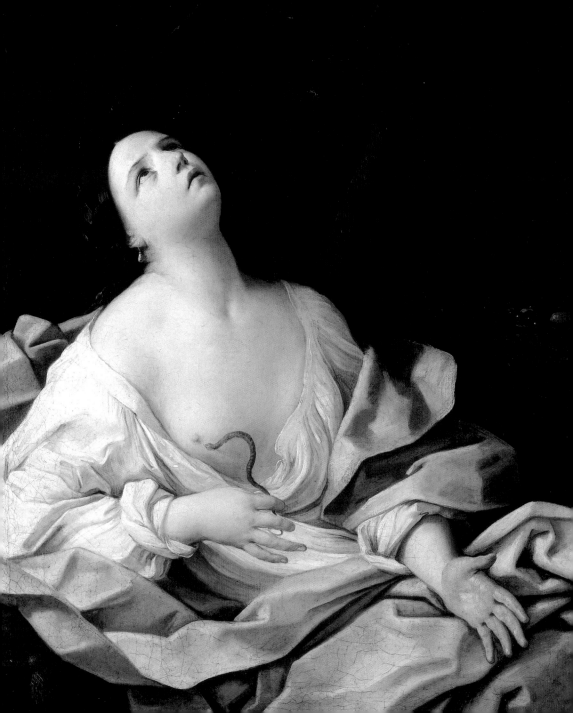

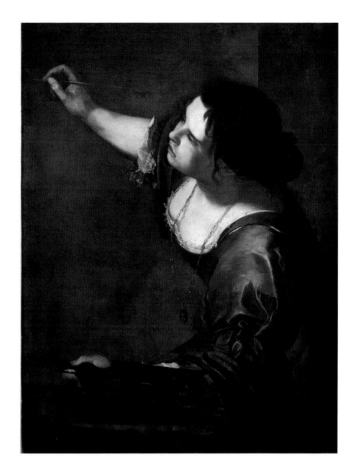

Left
77. GUIDO RENI
(1575–1642)
*Cleopatra with
the Asp, c.1628*
Oil on canvas, 114.2 x 95 cm

Palma Giovane asked his
friend and fellow artist
Guido Reni to create a
painting of Cleopatra to be
judged in competition with
his own works and those
of Niccolò Renieri and
Guercino. The painting
depicts the final moments
of the Egyptian Queen,
Cleopatra, as she prepares
to commit suicide from the
bite of the venomous snake
held delicately against
her breast. The dramatic
potency of the image is
heightened through the
stark contrast between
Cleopatra's fair skin and
the dark background.
Reni did not win the
competition, but Renieri
later bought the painting.

Above
**78. ARTEMISIA
GENTILESCHI**
(1593–1652/53)
*Self-Portrait as the Allegory
of Painting (La Pittura),
c.1638–39*
Oil on canvas,
98.6 x 75.2 cm

Artemisia Gentileschi was
one of the leading painters
of seventeenth-century Italy.
Like other female artists
of the age, she studied
with her father, in her
case, Orazio Gentileschi
(pls 64, 82). She was
invited to London in 1638
by Charles I, and probably

produced this sophisticated
and accomplished self-
portrait in England. She
holds a brush in one hand
and a palette in the other,
cleverly identifying herself as
the female personification
of painting – something
her male contemporaries
could never do.

79. Domenico Fetti
(1588–1623)
Vincenzo Avogadro, 1620
Oil on canvas,
115.4 x 90.3 cm

The inscription placed along the arm of the chair identifies the sitter of this powerful and mysterious portrait as Vincenzo Avogadro, Rector of the church of Santi Gervasio e Protasio in Mantua, and gives his age as 35. In his hands he holds a book, and in the upper left-hand corner of the painting is a crucifix. The luxurious fabric of the altarcloth and his richly coloured costume hint at Avogadro's noble standing. The nervous touch of Fetti's brushstrokes delineating Avogadro's face against the darkness gives the portrait a haunting quality.

**80. DOMENICO FETTI
(1588–1623)**
*The Sacrifice of Elijah before
the Priests of Baal, c.*1621–22
Oil on canvas,
68.4 x 82.3 cm

This work, possibly a
preparatory sketch for
a larger painting, was
probably made about the
time of Fetti's move to
Venice in 1622. It was
quickly executed, giving the
subject a dynamic quality. It
depicts the sacrifice of Elijah

to Jehovah (1 Kings 18: 38).
Elijah, kneeling on the right,
looks up at the fire of the
Lord that descends upon his
sacrificial offering. On the
left, Ahab, King of Israel
and the worshippers of
Baal recoil in horror as they
realise their god is false.

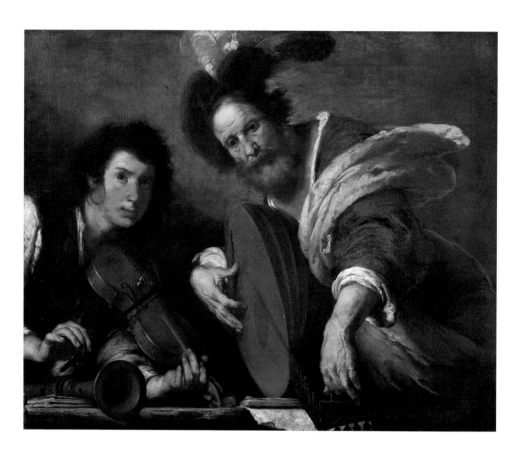

81. Bernardo Strozzi
(c.1581–1644)
*The Concert, c.*1635
Oil on canvas,
101.2 x 124 cm

Although traditionally called
The Concert, this painting
actually represents two
musicians tuning up.
A young violinist is
accompanied by a brightly
dressed older lute-player
with a large plumed hat.
Both figures gaze outwards
as if focusing their attention
on someone beyond the
picture plane. The tenor
shawm (a reed instrument
resembling an oboe) on
the table suggests they
may await a third player –
perhaps they are inviting
us to join them.

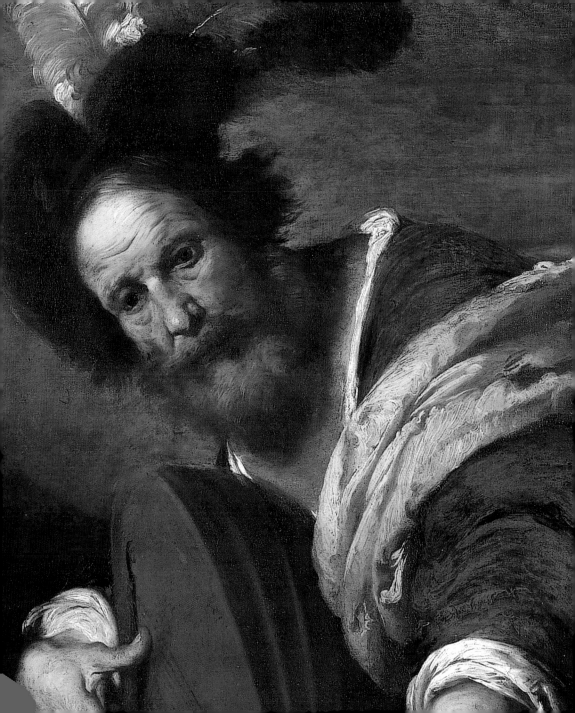

Below
82. ORAZIO GENTILESCHI
(1563–1639)
A Sibyl, c.1635–38
Oil on canvas, 59.9 x 68.7 cm

The twelve Sibyls were supposed to have foretold the coming of Christ and were adopted by the Church as pagan equivalents of the

Old Testament prophets. Gentileschi was in effect painter to Charles I's Queen, Henrietta Maria, and according to one

source was given the exceptional privilege of being buried under the main altar in her Chapel at Somerset House.

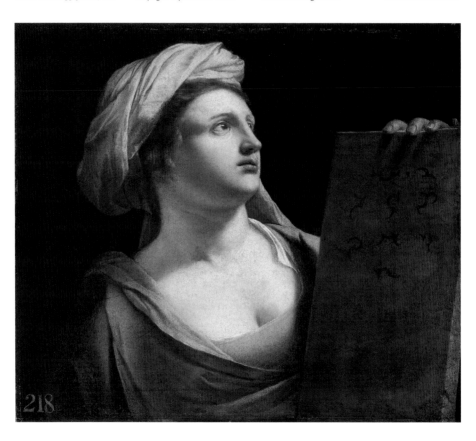

218

Right
83. GUERCINO
(1591–1666)
The Libyan Sibyl, 1651
Oil on canvas,
116.2 x 96.6 cm

This late work by Guercino ('The Squinter') is one of a pair of Sibyls painted for Ippolito Cattani of Bologna. It depicts the Libyan Sibyl who prophesied the coming

of Christ to the Gentiles. She is usually shown holding a lighted torch, but Guercino identifies her here by the inscription on the book. Charles I tried to lure

Guercino to the English court, but the artist declined on the grounds that the country was heretical and the climate terrible.

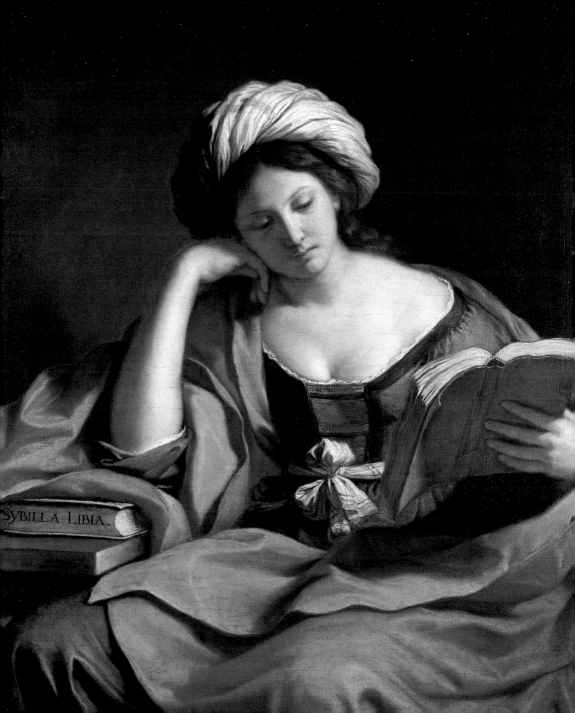

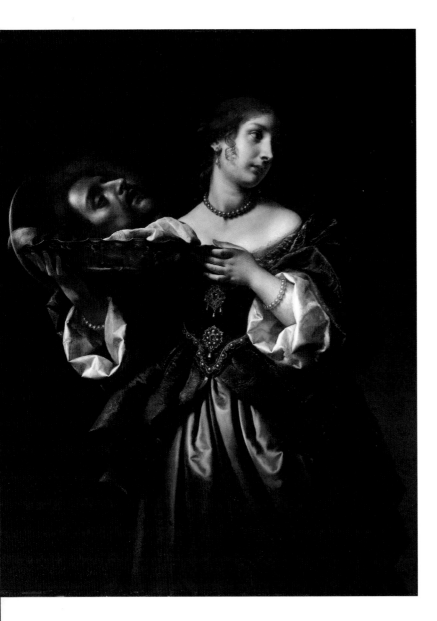

84. CARLO DOLCI
(1616–1687)
Salome with the Head of
St John the Baptist,
c.1665–70
Oil on canvas, 126 x 102 cm

Carlo Dolci spent most of
his working life in Florence
and was famous for his
emotive rendering of
religious subjects and his
highly polished portrait
studies. The melancholy
distraction of Salome and
the meticulous attention
to detail exemplify Dolci's
style. In the Bible story,
Salome's dancing had so
delighted King Herod that
he promised to give her
anything she wanted.
Prompted by her mother
Herodias, Salome asked
for the head of John
the Baptist, who had
denounced her mother's
incestuous liaison with
the King.

**85. Luca Giordano
(1634–1705)**
*Psyche's Parents Offering
a Sacrifice to Apollo,*
*c.*1695–7
Oil on copper,
56.2 x 69.2 cm

Luca Giordano painted
Apuleius's story of Cupid
and Psyche for the Spanish
royal family. The story
was told in a series of 12
paintings on copper, four of
which are reproduced here
(pls 85–88). Psyche is so
beautiful that the jealous

goddess Venus commands
her son Cupid to make her
fall in love with an unworthy
man. However, Cupid falls
in love with Psyche himself.
With no potential husband,
Psyche's parents consult
the oracle of Apollo.

86. Luca Giordano
(1634–1705)
Psyche Served by Invisible
*Spirits, c.*1695–7
Oil on copper,
57.8 x 68.9 cm

Psyche's parents are told
by the oracle of Apollo that
Psyche's future husband
is a monster and are
ordered to leave her on a
mountaintop. Psyche is

carried by Zephyrus,
the west wind, to Cupid's
palace, where invisible
spirits help her to
bathe and bring her
a magnificent feast.

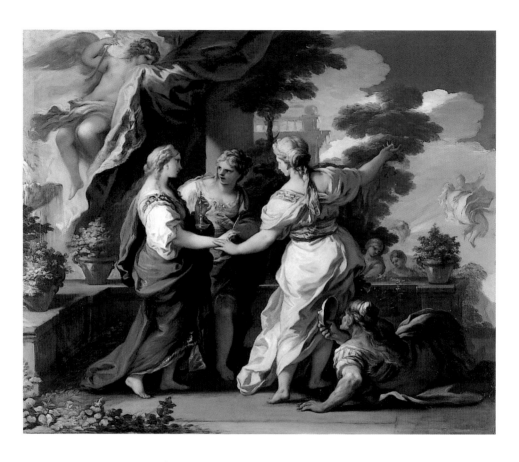

**87. LUCA GIORDANO
(1634–1705)**
*Psyche's Sisters giving her
a Lamp and Dagger,*
c.1695–7
Oil on copper,
57.5 x 69.9 cm

Cupid visits Psyche's bed
but does not allow her to
see him. When Psyche's
jealous sisters visit her they
convince Psyche that her
husband is a monster and
that she must kill him,
giving her a lamp and
dagger.

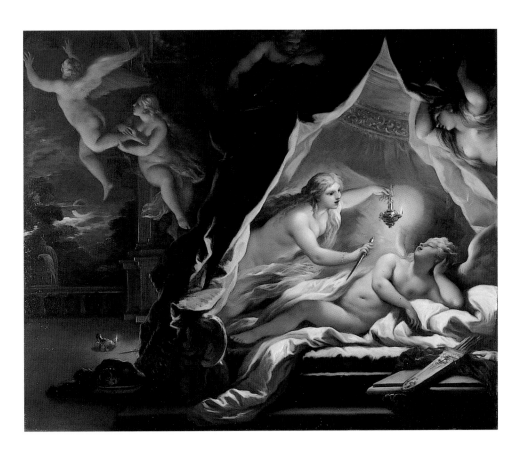

**88. LUCA GIORDANO
(1634–1705)**
*Psyche Discovering the
Sleeping Cupid, c.*1695–7
Oil on copper,
57.2 x 68.6 cm

Psyche illuminates Cupid's
beautiful figure with a lamp
while he sleeps, but a drop
of hot oil accidentally wakes
him and he flees. Psyche
eventually wins back his

love, the gods make
her immortal and she
is reunited with Cupid.
The set of 12 may be
unfinished as they tell
only half the story.

Left
89. LUDOVICO CARRACCI (1555–1619)
A Seated Male Nude,
c.1590 (detail)
Black and white chalks and
oiled charcoal on blue paper,
34 x 23.7 cm

Ludovico Carracci and his
younger cousins, Agostino
and Annibale, established
an academy in Bologna that
insisted on drawing from
the life as the foundation
of artistic practice. This is a
study for the Sala d'Eneide

in Palazzo Fava in Bologna,
painted jointly by the Carracci.
It depicts a companion of
Aeneas crushing a harpy.
The use of sticky oiled
charcoal led Ludovico
to simplify the form of
the powerfully built figure.

Above
90. GUERCINO (1591–1666)
A Recumbent Male Nude,
c.1618–19
Oiled charcoal with some
white chalk on buff paper,
the corners made up,
38.5 x 58 cm

As a young man Guercino
ran a life-drawing studio in
the town of Cento, emulating
the Carracci academy in
Bologna, fifteen miles
(25 km) to the south. The
model drawn here posed
often for Guercino and

appears in several drawings
and paintings of the period.
The technique of oiled
charcoal on toned paper had
been a favourite of the earlier
artist Pietro Faccini, whose
drawings Guercino is
reported to have admired.

**91. ANNIBALE CARRACCI
(1560–1609)**
*Polyphemus, c.*1597–8
Black and white chalks
on blue paper,
60.9 x 35.5 cm

After completing the
Camerino in Palazzo
Farnese, Rome (see pl. 92),
Annibale Carracci frescoed
the adjacent sculpture
gallery. This is a study for
*Polyphemus hurling the rock
at Acis,* at one end of the
vault. Annibale's frescoes
in the Galleria were the
seminal work of the
Baroque in Rome, and with
studies such as this he
single-handedly revived the
art of life drawing in the city.

**92. ANNIBALE CARRACCI
(1560–1609)**
*A Putto with a Cornucopia,
c.*1596
Black and white chalks on
dirty brown paper, the
outlines partly incised,
52.8 x 39.6 cm

Annibale Carracci left
Bologna in 1595 to work for
Cardinal Odoardo Farnese
in Rome. His first project
there was to fresco the
ceiling of Odoardo's study,
the Camerino in Palazzo
Farnese, with scenes from
myth and legend in a
decorative surround. This
was the full-scale working
cartoon for a putto sup-
porting a shield bearing
an allegorical figure.

Left
**93. BARTOLOMEO
SCHEDONI (1578–1615)**
*A Beggar, c.*1610–15
Red chalk, 43.3 x 35.8 cm

Schedoni worked for several
years for the Farnese in
Parma, and his paintings
and drawings show an
interest in earlier Parmese
artists such as Correggio
and Anselmi. This drawing
depicts a beggar holding
out his hand to receive
alms. Beggars appear in
several of Schedoni's
paintings, though no figure
in exactly this pose can be
found in any surviving work.

Above
**94. DOMENICHINO
(1581–1641)**
*St Jerome, c.*1612
Black and white chalks on
blue paper, 38.8 x 31.9 cm

Domenichino trained with
the Carracci in Bologna
before moving to Rome,
where his collaboration
with Annibale Carracci
positioned him as the
leading classicist of his
generation. This is one of
many surviving life studies
for perhaps Domenichino's
most celebrated work,
the *Last Communion of
St Jerome* (now in the
Pinacoteca of the Vatican).

Left
95. GUIDO RENI
(1575–1642)
An Angel with a Violin,
*c.*1613
Black and white chalks on
blue paper, 37.8 x 24 cm

The drawing is a study
for Reni's fresco of *St
Dominic in Glory*, in the
chapel housing the saint's
remains in the church of
San Domenico, Bologna.
Though drawn from a
model, Reni has added the
outlines of the angel's
wings. The strong faceting
here was a result of Reni's
use of a hard, scratchy black
chalk; the drapery in the
fresco is much more fluid.

Right
96. GUIDO RENI
(1575–1642)
The Head of Christ, 1620
(detail)
Red chalk, 34.4 x 26.7 cm

In 1620 Guido Reni
provided his assistant
Francesco Gessi with
designs, including this
sheet, for a painting
of *Christ the Saviour* as
the high altarpiece of
Santissimo Salvatore,
Bologna.

Left
**97. Ludovico
Carracci (1555–1619)**
*The Martyrdom of
St Ursula,* c.1614 (detail)
Pen and ink with grey and
brown wash and white
heightening over black
chalk, on buff paper,
48.9 x 38.6 cm, arched

St Ursula was a legendary
early Christian princess
from Britain, betrothed to
a pagan prince. She was
allowed to postpone the
wedding for three years,
and she and ten virgin
companions, each with
a thousand maidservants,
made a pilgrimage to
Rome. On their return
journey they were
slaughtered by the Huns
for their faith. Ludovico
Carracci painted the
Martyrdom of St Ursula
three times: this is a study
for the last version,
executed for Sant'Orsola,
Mantua, and now lost.

Above
**98. Guercino
(1591–1666)**
*The Burial and Reception
into Heaven of St Petronilla,*
c.1621–2
Black chalk, partly stumped,
with accidental touches of
red chalk, 51.6 x 37.8 cm

In 1621 Guercino's
Bolognese patron Cardinal
Alessandro Ludovisi was
elected Pope Gregory XV,
and Guercino followed
him to Rome. The Pope
commissioned from
Guercino a huge altarpiece,
to be placed over the
remains of St Petronilla

in St Peter's. The young
artist must have been
required to prepare this
model drawing for the
approval of his patron;
approval was evidently
not forthcoming, for the
altarpiece as painted
is very different in its
composition.

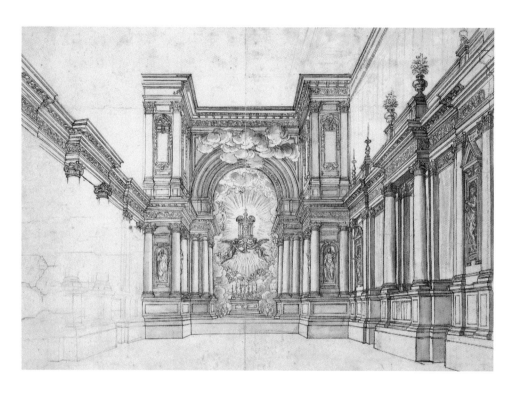

99. PIETRO DA CORTONA (1596–1669)
A Design for a Quarantore, c.1632–3
Pen and ink with wash over black chalk,
39.8 x 56.8 cm

In 1633 Pietro da Cortona was commissioned by Cardinal Francesco Barberini to construct an elaborate temporary setting in San Lorenzo in Damaso, Rome, for the *Quarantore* celebrations – forty hours of continuous devotion of the consecrated host. The decorations were constructed of quickly worked materials, with wooden architecture, sculptures in papier maché or stucco, and paintings in watercolours on thin canvas or linen. Nonetheless this was the most costly such apparatus ever built, and was used annually for the next fifteen years.

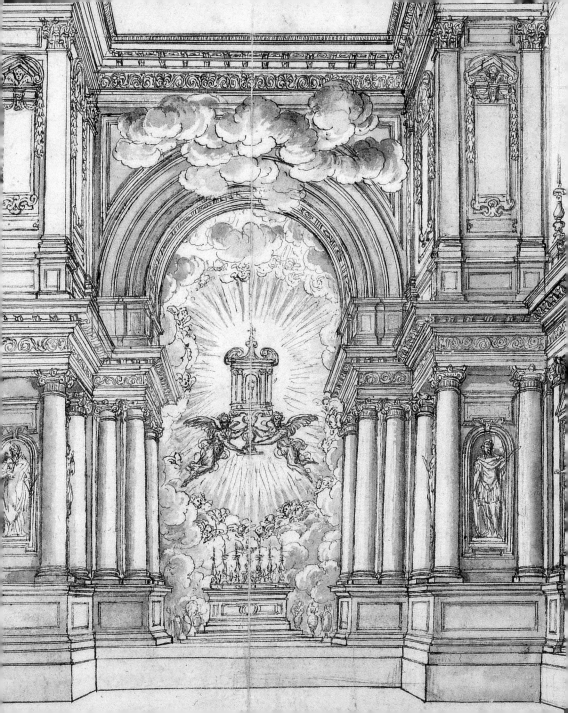

Previous pages
100. Nicolas Poussin
(1594–1665)
The Saving of the Infant Pyrrhus, c.1633–4
Pen and ink with brown wash over red chalk, 20.6 x 34.5 cm

Though French by birth, Poussin spent most of his career in Rome. This is a study for a painting of the *Saving of the infant Pyrrhus*, now in the Louvre. A legend recounts that the infant Pyrrhus was carried to safety when his father King Aeacides was driven from Epirus. Arriving at Megara with the enemy in close pursuit, his protectors found a river outside the city impassable; they threw across messages attached to a stone and a spear, and a boat was sent to rescue the child.

Above
101. Pietro Testa
(1612–1650)
Midas, c.1640–50 (detail)
Pen and ink over traces of black chalk, 20.8 x 27.2 cm

Pietro Testa was more a natural draughtsman (and etcher) than a painter, and a succession of frustrated projects led to his presumed suicide by drowning in the Tiber. This sheet is a fine illustration of his difficult character. It formed part of a letter to a patron, accusing him of trying to buy Testa off. In the letter Testa explained that the myth of King Midas symbolised the tyranny of those for whom nourishment (or friendship) is turned to gold (or seen in terms of money).

Right
102. SASSOFERRATO
(1609–1685)
*The Mystic Marriage of St Catherine, c.*1650?
Black and white chalk on buff paper, 42.2 x 27.4 cm

Sassoferrato worked in a deliberately old-fashioned style, painting both copies of works by earlier artists, especially Raphael, and his own compositions. This is a study for an altarpiece now in the Wallace Collection, probably painted for a church in Genzano, outside Rome. It depicts a vision of St Catherine of Alexandria in which the Christ Child placed a ring on her finger, making her his spiritual bride. At the saint's feet are the broken wheel of her attempted martyrdom, and the sword with which she was beheaded.

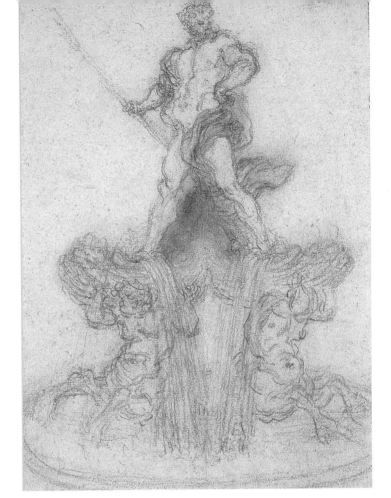

Left
**103. GIAN LORENZO
BERNINI (1598–1680)**
*A Male Nude from
Behind,* c.1630
Red and white chalks on
buff paper, 55.6 x 42 cm

Most of Bernini's drawings
are related to his sculptural
and architectural projects,
but a number of
independent drawn
portraits and figure studies
also survive. This is one
of four large surviving
drawings of the same
model, probably made
as demonstration pieces.
At the end of 1629 Bernini
reluctantly became head
of the artists' Academy of
St Luke for the following
year, and the drawings
have been associated with
his presumed teaching
responsibilities there.

Above
**104. GIAN LORENZO
BERNINI (1598–1680)**
*A Study for a Fountain
of Neptune,* 1652
Black chalk, 34.7 x 23.8 cm

Bernini was called upon to
produce far more sculpture
than he could ever carve
himself, and most works
of his maturity were
executed by others to his
designs. This is a study for
one of several fountains
commissioned by
Francesco d'Este for the
courtyard of the Palazzo
Ducale at Sassuolo, near
Modena. The sea-god
Neptune stands astride
two shells supported by
sea-centaurs. An assistant
prepared clay models
on the basis of Bernini's
drawings, from which local
craftsmen executed the
fountains in stucco.

105. GIOVANNI BENEDETTO CASTIGLIONE (1609–1664)
*The Head of an Oriental, c.*1655
Monotype, with retouching and wash, 31.7 x 23.6 cm

Castiglione seems to have invented the monotype process, in which an image is drawn with oils or printing ink onto a metal plate, from which a few paper impressions can then be taken. Here he also scraped details into the ink, most noticeably in the turban, beard and fur collar, and applied additions to the print with both ink and a brown wash. Castiglione was very fond of exotic heads such as these, inspired by the etchings of Rembrandt.

106. CLAUDE LORRAIN (c.1605–1682)

Acis and Galatea, c.1657
Pen and ink with wash and
white heightening, over
black and a little red chalk,
on paper washed brown,
35.3 x 46.5 cm

Claude moved to Rome as
a youth and worked there
for the rest of his life. This
is a study for a painting
depicting the myth of Acis
and Galatea, as recounted
in Ovid's *Metamorphoses*.
The cyclops Polyphemus
was infatuated with the
sea-nymph Galatea, but
was spurned by her in
favour of the youth Acis.
Here Acis and Galatea
embrace, while Polyphemus
sits with his flocks in the
distance, playing his pipes
and singing the praises of
Galatea.

**107. GIOVANNI BENEDETTO
CASTIGLIONE (1609–1664)**
*Circe, c.*1650–55
Brown and red-brown oil
paint on paper, 39.4 x 56 cm

Castiglione was a
technically adventurous
artist who produced
hundreds of drawings in
oil paint on unprepared
paper, mostly independent
works of art rather than
studies for paintings.
The flowing strokes of the
brush that this technique
allowed were ideally suited
to Castiglione's verve as a
draughtsman. This sheet
depicts the sorceress
Circe surrounded by the
companions of Odysseus,
whom she has turned into
animals, and whose clothes
and armour lie on the steps
before her. Compare
Stradanus's treatment of
the same subject in pl. 16.

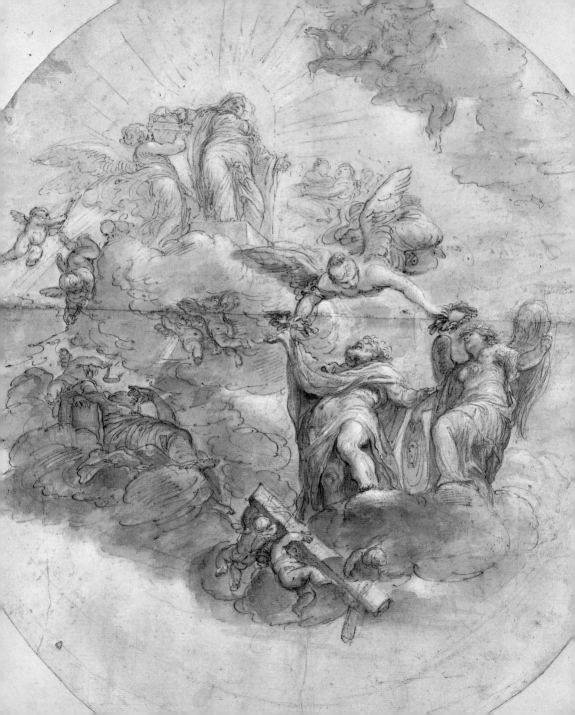

Left
108. DOMENICO MARIA CANUTI (1625–1684)
An Allegory of Divine and Human Wisdom,
*c.*1677–80
Pen and ink with wash and white heightening over red chalk, 43.5 x 39.1 cm

Late in his career Canuti frescoed the ceiling of the monastery library of San Michele in Bosco outside Bologna. The allegory in the central dome depicts Divine Wisdom, gesturing down towards the winged Glory who bestows laurel wreaths on Merit and Virtue. Among the clouds at lower left is the benighted Human Wisdom, on whom fall only a few shafts of the divine light.

Above
109. GIOVANNI BATTISTA BEINASCHI (1636–1688)
*A Prophet, c.*1680
Black and white chalks on brown paper, 49 x 34.8 cm

The construction of the dome of Santi Apostoli in Naples was completed only in 1680, long after Giovanni Lanfranco had finished his cycle of paintings in the body of the church. Over the next two years Beinaschi filled the vault of the dome with a fresco of *Paradise with Christ in Glory*. This is a study for one of the prophets in the fresco.

Left
**110. CARLO MARATTI
(1625–1713)**
*St John Expounding the
Doctrine of the Immaculate
Conception, c.*1684–6
Pen and ink over red chalk,
on paper washed pink,
50.3 x 29.1 cm

Carlo Maratti was the
leading exponent of
classicism in late Baroque
Rome. This is one of many
studies for his altarpiece in
the Cybo chapel of Santa
Maria del Popolo, painted in
oils directly on to the wall of
the chapel. It depicts St John
the Evangelist explaining the
Immaculate Conception to
three Doctors of the Church,
Saints Gregory, Augustine
and John Chrysostom.

Right
**111. GIOVANNI GIUSEFFO
DAL SOLE (1654–1719)**
*Susannah and the Elders,
c.*1680–1700 (detail)
Grey-brown and white oil
paint on a printed page,
38.2 x 26.3 cm

The drawing is one of many
executed by Dal Sole in
monochrome oils on a
page from a printed book.
It depicts the virtuous
Susannah surprised while
bathing by two elders, who
threatened to accuse her of
adultery if she did not give
herself to them. She refused,
and at the subsequent trial
the young Daniel caused the
elders to give conflicting
evidence; their fabrication
exposed, the men were
sentenced to death.

**112. DOMENICHINO
(1581–1641)**
*The Flagellation of
St Andrew*, c.1622–5 (detail)
Red chalk, squared
44.5 x 56.8 cm

Domenichino's greatest
work in Rome was his
fresco cycle in the church
of Sant'Andrea della Valle.
This is the final design
for *The Flagellation of
St Andrew*, which occupies
an irregular curved space
in the vault. It was preceded
by many individual life
studies; here Domenichino
arranged the figures in
the perspectival space,
before transferring the
composition to a full-scale
cartoon with the aid of the
curving squared grid.

Further Reading

A. Blunt and H.L. Cooke, *The Roman Drawings of the XVII and XVIII Centuries in the Collection of Her Majesty The Queen at Windsor Castle*, London 1960

J. Brown, *Kings and Connoisseurs: Collecting Art in Seventeenth-Century Europe*, Princeton 1995

J. Brown and J. Elliott (eds.), *The Sale of the Century: Artistic Relations between Spain and Great Britain, 1604–1655* (exh. cat., Museo del Prado), New Haven and London 2002M. Clayton, *Holbein to Hockney: Drawings from the Royal Collection*, London 2004

S. J. Freedberg, *Painting in Italy 1500–1600*, London 1990 (2nd edn)

P. Humfrey, *Painting in Renaissance Venice*, New Haven and London 1995

O. Kurz, *The Bolognese Drawings of the XVII and XVIII Centuries in the Collection of Her Majesty The Queen at Windsor Castle*, London 1955 (reprinted 1988)

M. Levey, *The Later Italian Pictures in the Collection of Her Majesty The Queen*, Cambridge 1991 (2nd edn)

J. Martineau and C. Hope (eds.), *The Genius of Venice 1500–1600* (exh. cat., Royal Academy of Arts), London 1983

A. MacGregor (ed.), *The Late King's Goods: Collections, Possessions and Patronage of Charles I in the Light of the Commonwealth Sale Inventories*, London and Oxford, 1989

O. Millar, *The Queen's Pictures*, London 1977

A.E. Popham and J. Wilde, *The Drawings of the XV and XVI Centuries in the Collection of His Majesty The King at Windsor Castle*, London 1949 (reprinted 1984)

J. Roberts (ed.), *Royal Treasures: A Golden Jubilee Celebration*, London 2002

J. Shearman, *The Early Italian Pictures in the Collection of Her Majesty The Queen*, Cambridge and New York 1983

A. Sutherland Harris, *Seventeenth Century Art and Architecture*, London 2005

L. Whitaker and M. Clayton, *The Art of Italy in the Royal Collection: Renaissance and Baroque*, London 2007

R.W. Wittkower, *Art and Architecture in Italy 1600–1750*, Baltimore 1958

Index

Page numbers in italics are for illustrations and page numbers in roman type are for textual references.

Next page
LUDOVICO MAZZOLINO
(c.1480–c.1528)
Warriors (detail)
(see pl. 23)